REALISATION
FROM SEEING TO UNDERSTANDING
THE ORIGINS OF ART

JULIAN SPALDING

WILMINGTON SQUARE BOOKS
an imprint of Bitter Lemon Press

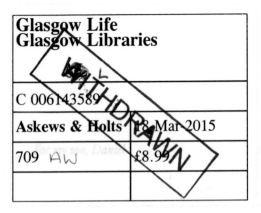
WILMINGTON SQUARE BOOKS
An imprint of Bitter Lemon Press

First published in 2015 by
Wilmington Square Books
47 Wilmington Square
London WC1X 0ET

www.bitterlemonpress.com

A CIP record for this book is available from the British Library

ISBN 978-1-908524-454

9 8 7 6 5 4 3 2 1

Designed and typeset by Jane Havell Associates
Printed in the UK by TJ International, Padstow

Contents

Contents

Foreword

One of my earliest memories is of sitting on a quay at the seaside watching a stick floating on the water. The waves were passing below me, under my kicking legs – I was still wearing short trousers – but, to my great surprise, the stick wasn't carried along with them; it stayed exactly where it was, rising and falling as the waves rolled past. It seems to me now, looking back, that my life has been like that stick: time has rolled through me, like a wave, but I haven't changed; I've stayed me. Even now, despite the intervention of so many years, I feel I'm that same young boy, who can slip easily into sensations of wonder.

I remember the thrill of watching a snail's eyes growing out of its slimy back as it emerged from its shell, seeing beads of dew glinting rainbow colours in the sun at dawn, and gazing, with bewildered amazement, on a wintry night, up at the Milky Way plumed across the sky. This was easy to see sixty years ago, even in cities. Most extraordinary of all was the invisible, ceaseless and – to a small boy about to start school – terrifyingly unstoppable flow of time through everything.

Later, during my long career in art galleries and museums, my ambition was to help visitors make imaginative leaps back into the minds of the people who had created the rare treasures in my care. But I soon discovered how difficult that was. The problem was that the thoughts of the people who had carved an Egyptian god, modelled a Tang Dynasty horse or painted a Renaissance altarpiece were so far removed from the day-to-day concerns and interests of my twentieth-century public. I wrote about this challenge in *The Poetic Museum – Reviving Historic Collections*. Later, in *The Art of Wonder – A History of Seeing*, I tried to demonstrate how art has always been the product of our attempt to make sense of the mysteries around us. I treated the subject thematically, explaining what our ancestors had thought about the basic polarities of our everyday experience – birth and death, day and night, up and down – and demonstrated how the European Enlightenment dramatically altered our understanding of what had until then appeared to be fundamental facts of life.

Then it dawned on me that the way human beings have made sense of the world has in fact passed through a series of radical changes that can be tracked over time; surprisingly, many of these early world views still linger in our thoughts today, as ghostly images of bodies and trees, pyramids, altars and veils. I became increasingly interested in examining the light which our intelligence throws on the world, and our sense of the darkness beyond our grasp. The extensive writings on the nature of human consciousness by the physician, philosopher and polymath Raymond Tallis had a profound influence on the development of my thinking, and he gave me crucial, detailed advice about the book's final form. The newspaper editor John McGurk suggested the title.

I am indebted to the late Sir Graham Hills, Principal of the University of Strathclyde, who encouraged me to write an unanno-

tated book which said what I thought rather than spending all my time summarising others' opinions.The qualifying insertions of 'maybe', 'possibly' and 'might' have been largely eschewed to avoid tedium, but also because this is a book about ideas, many of which will remain conjectural and almost all of which are allusive. The conclusions I have reached are based on fresh insights that have come to me from studying real objects in museums and visiting many historical sites around the world, not through second-hand experiences gained from other people's writing, though a vast amount of reading has enabled me to reach these conclusions. I have included an extremely condensed bibliography, not because I necessarily agree with what these books have to say, but to highlight some of the key texts that have influenced a lifetime's research, and to enable my readers to find out more about the myriad aspects of human history covered by this short book.

My approach isn't academic, but an attempt to combine scholarship with poetry in a way that brings us closer to the thinking and feeling of people in the past – who were, like us, full of love of life, fearful of death and just as bewildered by the meaning of everything. My ambition has been to take my reader on an imaginative journey back into the past, to show how our ignorance has persisted alongside our extraordinary leaps of understanding. This is, therefore, not a conventional history, but neither is it fanciful, for our world pictures have always been built on what we perceived to be common sense.

JULIAN SPALDING
2014

Flowers of Common Sense

Great works of art catch the popular imagination in ways that are difficult to express in words. The pyramids, Chartres Cathedral, the Taj Mahal and paintings such as the *Mona Lisa* all chime with our perception of the mystery of our existence, and although they were created in ages very different from our own, they resonate in our minds as if they had always existed. We've built a world civilisation on these famous but elusive images; they're the substantial evidence of our insubstantial heritage. But their meaning isn't beyond our grasp: it's to be found in the history of our collective consciousness, in the way that our shared views about who and where we are have changed over time.

A world picture begins to take shape in the human mind when we go through that phase, common to all young children, of continually asking questions – why the sky is blue, why the rain is thin, why living beings die – until the grown-ups around us run out of explanations, and patience. Their replies might well affect our

behaviour – you don't dig into the earth, for example, if you believe that she is your mother, is very much alive, and will punish you if you hurt her. But soon we begin to realise that very few of the general, all-encompassing truths we've learnt make any difference to our immediate lives. So, in a hurry to grow up, we give up asking childish questions and start acting on adult assumptions. That's when our thoughts begin to crystallise into an image of the world, a silky cocoon of comprehension which protects us from the dark, uncomfortable uncertainties beyond.

World pictures are shared images of common sense, that apparently firm surface on which we write the purported purpose of our lives, within the bounds of what we believe to be the facts of our existence. People have always realised that they didn't know how far this luminous arena of their lives extended: no one could conceive of the ends of the universe, and we still can't, despite all the remarkable discoveries of science. Nevertheless, we have always thought that we have a pretty good idea of where we are, of the shape of the place we inhabit. We call this realism; it gives us a firm basis for our lives, a ground to act on and grounds for action. And we have always assumed that this reality is an eternal truth.

In fact, our sense of what is real has changed dramatically over time. We now see the human race as leading a precarious existence, within a bubble-thin atmosphere, hanging on to a tiny orb suspended in the immense hostility of space. Trillions of particles are spinning inside us and trillions of galaxies whirling around us, in a universe which is expanding in all directions, like an unimaginably vast, slowly inflating bubble. This is a radically different concept from that of our ancestors, who thought that they were at the fixed centre of everything, standing on a flat, square, solid earth under the rotating dome of heaven. But despite these changes in perception, we still feel that we have our feet firmly on the ground, as they

did. Our 'here' – whether it's a flat plane, or a sphere of jiggling atoms more full of emptiness than anything else – has always been here, and 'here' is as down to earth as you can get. We can stub our toes on it. And die in it. All of our world pictures in the past, no matter how bizarre they might seem to us today, were expressions of realism.

It never occurs to us that a different world view will develop in the future. We can resist taking new ideas on board for a very long time, but when a fact becomes incontrovertible – for example, when Galileo focused his telescope on the turning moon – we can change our thinking almost overnight, as if we'd never believed that the sun went round the earth. It's a strange trait of human minds that while knowledge can be superseded, it can't consciously be unlearnt. We might forget we know something, or pretend that we don't know it, but we can't shake off new understanding. After Galileo had signed the papers retracting what he was told to call his 'suspicions' that the earth travelled around the sun, he reputedly muttered under his breath, 'And yet it *does* move.' Once truths have burst into our minds they become remarkably stubborn presences, the pillars of wisdom on which we build our lives.

World pictures are fixed and persistent while we hold them, but they're also elusive because they're never explicitly described. They don't need to be – everyone assumes them to be true. If you went around today telling people that the earth was a sphere, it would be considered very strange behaviour, just as strange as if you'd gone around a millennium ago saying it was flat, when everyone knew it was. Immense monuments such as the Great Pyramid, Chartres Cathedral or the Taj Mahal were clearly not the products of lightweight thought, yet it is highly unlikely that any contemporary documents ever existed which explained the rationale behind the forms they took. These extraordinary creations, numbered

among mankind's greatest achievements, were nothing more, nor less, than flowers of common sense.

Flowers have haunted our imaginations throughout history, from the lotus blossoms on which the Buddha meditated, expressing his attainment of enlightenment, to the rose windows in Gothic churches which symbolise the purity and fecundity of the Virgin Mary; from the flower-studded benches where the Aztec Eagle Warriors sat before they sacrificed their lives, to the roses which the Mughal emperors were shown holding in their hands, representing the sweet-perfumed order they had brought to their land. These were flowers which blossomed in the human mind, evoking our aspirations for peace, health and harmony in the world around us, and for spiritual attainment in the world beyond. Flowers lost the poetic bloom of their significance when scientists discovered that they were only the sexual organs of plants, though their symbolic meanings still linger at weddings and funerals.

As old world pictures slip from use, they fade and become mere shadows of their former selves, shorn of the elusive tentacles of meaning that once made them shine in our minds. This is true in fact as well as in thought. Smooth white marble originally covered the Great Pyramid at Giza; now it's a dark, jagged shadow in the desert. Chartres Cathedral used to be as vibrantly colourful on the exterior as it was within; today its gloriously glazed interior is enclosed in a shell of sombre, scrubbed stonework. The walls of the Taj Mahal were long ago stripped of most of their precious and semi-precious jewelled inlays, leaving the delicately carved leaves and petals as barren as the municipal lawns that now flank its fountains, which in their turn once sparkled among scented flowerbeds as colourful as the Taj's walls.

World pictures of the past were, almost without exception, images of the future as well as the present. For most people, the after-

life was far more important than their fleeting existence on earth, which through countless generations was filled with pain, discomfort and grief. Funerals were major, public reminders of mortality, with everyone draped in black in the west, or white in the east where that was the colour of death. Hearses moved at a walking pace along city streets, passers-by doffed their caps and all traffic slowed. Now funerals are colourful, seen as an opportunity to celebrate the life of the departed, and the death itself is scarcely mentioned. Our sun-centred universe has changed our attitude to mortality and given us a comparatively sunny disposition. In the past the sun really did die every day, and in a most unaccountable way. It requires a considerable effort for us to imagine a time when death was for everyone a vivid, daily presence, a grinning, animated skeleton holding an hourglass and scythe, walking just behind us, our partner in life whom we could no more escape than we could our own shadow. We believed in an afterlife, but no one knew what it was like any more than anyone knew what happened to the sun when it set, before it was reborn at dawn.

Our ancestors were fascinated by what seemed to be a paradox: although we look forwards, we can't see into the future. Having eyes on the front of our heads is an attribute we share with very few other creatures. (The main exceptions are apes and monkeys, cats, owls, a few dogs we've specially bred, and the odd fish.) Animals which have an eye on each side of their heads are alert to dangers both behind and in front of them, but their main focus is on the here and now, where they actually live. Humans are different. We confidently cast the luminous spotlight that is our conscious awareness of existence on to the path in front of us. We deceive ourselves that we can see what's ahead, trusting that life will continue as it always has, though in reality each step we take into the future is a step in the dark. We are always at risk. Our growing obsession with health

and safety issues in minor matters, such as children's playgrounds and office practice, is a sign that we are, once again, becoming increasingly uncertain about our future but do not know how to cope with the greater threats we face.

Our ancestors placed great trust in fortune tellers, who were consulted – as they still are in rural India, South America and China – before any major undertaking, such as a marriage, journey or business transaction. Above all, the future could be read in the mysterious movements of the stars, which, being much higher up than human beings, we believed could see a great deal further ahead. Though billions of people still consult their 'stars' and read their horoscopes, most of us find it difficult to empathise with our predecessors who lived in daily fear, beset by annihilating forces that they never anticipated anyone would fully comprehend. We dismiss these ancient fears as superstitions, and are reluctant to treat them seriously. But if we are going to understand world pictures of the past, we can't think of them clinically, in a modern scientific way; they have to be evoked imaginatively, for the truths at their core were mysteries rather than calculations. This is why we find them difficult to comprehend, or even countenance.

The very idea of a world view is now anathema to us as we assume it was for people in the past. In recent decades, scientists have found out so much about every aspect of the universe that it seems inconceivable that any single individual will ever be capable of combining all this knowledge into one coherent whole. And if someone were able to, hardly anyone else would expect to understand their concept. Though most people have heard of Einstein's general theory of relativity, very few would claim to have a clear grasp of what it actually means. The co-creator of quantum electrodynamics, Richard Feynman, once said, 'I think I can safely say that nobody understands quantum mechanics.' Even more confusingly,

these two models of the universe, one of immensity and the other of minutiae, are currently incompatible. The principle known as string theory attempts to tie them together, but it remains, so far, theoretical. In fact, our very acceptance of the limits of our knowledge is part of our current world picture, but, ironically, this is one aspect which makes it much closer to ancient perceptions than we might realise.

Though most of us still claim to believe in something called common sense, we are increasingly unsure what this is exactly. Scientific discoveries about the universe don't 'make sense' in the way we generally understand the term, but this has long been the case. It still doesn't 'make sense' that the earth goes round the sun; we continue to talk about the sun going down, never the earth appearing to rise as it turns. But science today is discovering facts that can only be described as absurd. According to Einstein's theories, if one twin travelled in a spaceship at almost the speed of light, he would come back younger than the twin who stayed on earth. Furthermore, if a ladder was travelling that fast, it could be fitted into a garage that was too small for it. Such statements seem nonsensical, but theories like these have explained a great deal about what actually happens in the universe. How our universe works is beyond the grasp of the vast majority because, for us, knowledge remains based on our sensed experience. It is significant that scientists have come to refer to this home-based knowledge as 'intuitive' understanding, thereby implying that common sense is a primitive instinct (often associated with women) and a throwback to our animal ancestry, rather than the product of conscious thought.

The advance of technology has clothed these astonishing scientific mysteries in a coat of comprehensible familiarity. We now accept as unremarkable a whole raft of inventions that would have engendered utter awe, deep suspicion or extreme fear in previous

generations. Most of us haven't a clue how computers, mobile phones or even televisions actually work, but we don't find them mysterious because they obey us at the flick of a switch. This makes it very difficult for us to imagine an age when the most basic physical phenomena – a flickering flame, a shower of rain or a bolt of lightning – could have been regarded quite sensibly as signals from a god, or to appreciate how the discovery of the hidden force of polar magnetism, first tracked by the Chinese with their compasses, could have been employed to maintain order in their vast empire for over 2,000 years, due to their belief that the emperor could sustain public harmony by performing rituals along a north–south path.

Science has blunted our everyday sense of wonder. We are more easily enchanted by phenomena we don't understand. What we already know bores us: it's common knowledge and not worthy of scrutiny. Our obsessive desire to understand cause and effect separates us from all other creatures. It's only by making a conscious effort that we can marvel, once again, at the dawn chorus, the changing shapes of clouds or the pulse of a beating heart. This imaginative journey into the past appears to be a retrograde step towards ignorance, in the opposite direction of the advancement of science. But we have to re-legitimise superstition if we are going to understand and appreciate the achievements of humanity.

Who humanity is – who 'we' are – is gradually becoming much more clear. In recent decades, geneticists have traced modern human DNA back to an original 'Adam' and 'Eve', the father and mother of us all. Both emerged in Africa, though apparently not at the same time. 'Eve' seems to have appeared about 143,000 years ago, but another 84,000 years or so were to pass before a male as sapient as her came along. However, it probably wasn't the case that women spent these millennia repeatedly giving birth to bright daughters and dim-witted sons. The experts think that DNA devel-

oped somewhat like a mosaic, and thus far they've only been able to trace back parts of it. But given men's assumed and accepted superiority for most of human history, it would be a tragic irony if the female of our species proved in the end to be the more precociously human of the sexes.

The lines of hominid evolution are extremely difficult to trace because the evidence is so fragmentary. It took us a long time to get round to looking for it, because for most of our history it never occurred to us that people had such a past. We used to imagine that humanity originated as a *tabula rasa*, created, most assumed, by a god. Hindus and animists believed that human souls could jump species, and spirits of ancestors could inhabit a tiger, whale or eagle. But it was only in the mid-nineteenth century that we discovered that we were descended from other types of humans, and that our genus shared its ancestry with apes. It was then that we unearthed the remains of our closest relatives. We later called them *Homo sapiens neanderthalensis*, after the place in Germany where their bones were first found, and reclassified ourselves as *Homo sapiens sapiens*, the wisest of the wise.

Neanderthals occupied Europe and the Middle East for 250,000 years, long before our ancestors from Africa began to invade their territory. The picture that emerges, from the sparse remains that have been found, is that the Neanderthals were a large type of human who hunted in groups with basic weapons, clothed themselves and built simple shelters. There is some evidence that they buried, or at least purposefully disposed of their dead, but nothing suggests that they did this with a view to preparing the deceased for an afterlife. Nor, it seems, did the Neanderthals make works of art. Recent discoveries in Spain suggest that they might have decorated themselves with painted shells, but collecting attractive things, as bowerbirds do, is not the same as creating art.

What is certain is that they lived in similar terrain to that of our ancestors until about 30,000 years ago, when Neanderthals apparently became extinct. The likelihood is that *Homo sapiens sapiens* was responsible for wiping them out, by enslaving or slaughtering them, as well as interbreeding with them. The few survivors were probably driven away into inhospitable territory where they eventually died out, perhaps in relatively recent times, leaving behind folk memories of wild, hairy men of the woods and mountains. The oldest known story in the world, the Epic of Gilgamesh, can plausibly be interpreted as a folk tale evoking our ancestors' complex relationship with Neanderthals, and feelings of guilt and sorrow at their demise.

This Sumerian epic tells of Gilgamesh, the idle son of a clan chief, who is overbearing and boastful, forever picking fights and always winning. He is so irritating that the gods create a wild, hairy giant, Enkidu, who is strong enough to put him in his place. Enkidu lives in the forest, and is a friend to all the animals. He can speak all their languages, but not that of man, and he annoys the hunters and farmers by freeing the animals they catch in their traps. So the men decide to set a trap for him. They persuade a beautiful young girl to stand near the forest pool where he comes to drink. He falls in love with her on sight, and they make love. After this, the animals desert Enkidu: they smell mankind on him. From then on he has to live with men, and learn their language.

One day Enkidu meets Gilgamesh, and they immediately fight to see who is the stronger. Neither wins, but instead they become inseparable friends, who together carry out increasingly daring raids, which end with their killing the Bull of Heaven. The gods, realising that they've doubled their trouble, kill Enkidu. But the story doesn't end there. Gilgamesh, heartbroken at the loss of his friend, travels to the end of the earth to see if he can conquer

Death. The gods tell him that he can try, but only if he can prove himself first by overcoming Death's little sister, Sleep. As soon as he sits down to begin the trial, Gilgamesh dozes off, and so he's sent back, ignominiously, to live the life of a mortal man. The Epic of Gilgamesh is a poignant tale, not just about the loss of our close relationship with nature and the demise of our nearest relatives, but also of the emergence of our consciousness of our own mortality, the very factor that distinguished us from Neanderthals.

It might seem incredible that a story written down in Mesopotamia (present-day Iraq) in about 2000 BCE could refer to the extinction of the Neanderthals, an event that happened some 30,000 years before. But we know that like all the great early tales of mankind – the Iliad, the Mahabharata, the books of the Old Testament – it was narrated by generations of storytellers long before it was transcribed. These stories survived precisely because they were memorised. The extraordinary, immense and rambling Chinese story *The Three Kingdoms*, which describes, with considerable historical accuracy, the warring factions and bizarre personalities of China in the 2nd century CE, wasn't written down until some twelve centuries later. However, lists of its myriad chapter headings – memory triggers for storytellers – survive from the intervening centuries, and they are virtually identical with those in the first written version of the story.

The invention of writing didn't improve our capacity to remember; rather, it enabled us to forget. (All authors will identify with the experience of waking in the night with sentences going round and round in the mind; only after scribbling them down can they get back to sleep.) Writing was a boon because it meant that we no longer had to carry so much information around in our heads: we were free to think of new things. Writing unchained us from the past. It enabled us to break from tradition, and eventually provided

the springboard for the scientific Enlightenment which would change our perception of time. The past was much closer to us before we had writing. Keeping ancestors alive in our minds was our greatest responsibility (as it still is among traditional Australian Aborigines) for if we forgot their stories, then our forefathers would truly die. In a culture without the written word, millennia were compressed in our collective memories. The past was relived in the present, as if it was yesterday.

The founding fathers of the world's faiths were aware of the danger when the stories central to their beliefs, which had previously been remembered and retold by word of mouth, began to be written down. Texts could be questioned and, even worse, the ideas in them forgotten. Religious leaders countered this threat by making their new writings sacred, not the guttural utterances of men, but divine words set in stone by gods. The Hindu Vedas, the Buddhist Dhammapada, the Old and New Testament and the Islamic Koran all became holy scriptures to be learned and recited by heart, as the stories of our ancestors had been of old, except that now they could be checked for textual accuracy and orthodoxy. So scrolls and tomes were used as pedants' rods to beat lines into wayward youths; texts became prison bars, trapping wandering and exploring thoughts. Dogma drained the free flow of the spoken word. And writing, that extraordinary invention of the human mind, was prevented from becoming a door opening on to adventure, until the European Enlightenment freed it from the vice-like grip of clerics.

Our earliest world views took shape long before we developed writing. Until very recently, our past was divided into history proper, starting from the time when people's thoughts began to be written down, and the woolly, preamble period of prehistory, the age before writing. Many historians still remain extremely cautious about using artefacts, such as paintings, sculptures and pottery, as

historical evidence if they aren't backed up by texts, though created images are clearly indicators of human thought as much as words. It could in fact be argued that they have less potential to deceive, because words can so easily lie, obscure or wilfully confuse. The value we've given to the written word is part of our own, contemporary world picture, which has itself eradicated earlier world views based much more substantially on images. As a result, a whole ocean of evidence of ideas which were expressed through art and artefacts has been demoted or simply overlooked. Images play a large part in the story of world pictures because they reflect the shapes of thoughts which we might have found difficult to express in words, even if we had seen the need to do so.

Now that we've come to see the human race as incorrigible explorers both mentally and physically, destined 'to boldly go where no man has gone before', we can't help projecting this view of ourselves back on to our ancestors. The extraordinary expansion of the human population around the globe which occurred between 60,000 and 40,000 years ago is generally attributed to mankind's inner drive, our adventurous spirit. But in reality the initial growth in our *Lebensraum* probably happened very differently. Although our species is naturally curious, everything indicates that we're territorial creatures, homemakers at heart.

This instinct is strongly connected to our sense of sight. If you've been away for a long time, you know you're getting nearer home when you begin to see familiar sights, and feelings can easily overflow into tears when your house itself finally comes into view. Many people still want to bring up their families where they themselves were reared, and it's very common to feel the pull of home when death draws near. We've always fought fiercely to defend our hunting and breeding grounds, and if we did set out to explore, our aim was always to bring our trophies back.

We may have romantic ideas now about the wandering life of ancient nomads, but in fact these tribes were highly territorial, repeatedly traversing a set terrain rather than roaming freely wherever the fancy took them. If groups of people left their homelands forever, it was generally because of shortage of food, most often caused by overpopulation. Our ancestors edged around the world out of necessity, rather than with a view to discovery. We've always felt ourselves to be centred, and this has had a huge impact on how we've seen the world and how we've viewed each other. Our concept of centrality, our homing instinct, was crucial to the development of all our earliest world pictures.

The marked differences in the physical appearance of human beings wouldn't have developed if our ancestors hadn't liked staying put for thousands of years. It has only recently been accepted that the most major of these differences are the result of adaptations to the environments we inhabited. Darker pigmentation protects the body from harmful solar radiation, hence the 'black' skin of those people whose ancestors lived near to the equator for many generations. Pale skin resulted from our need to maximise the absorption of vitamin D from weak sunlight, so people with 'white' skin first evolved in cooler northern climes. Smaller nose channels and narrowed eyes are adaptations which developed to protect the lungs from freezing air and the eyes from snow blindness, in those people who lived in the far north. When, comparatively recently in our history, small numbers of our species began to travel widely, they naturally and logically – though quite erroneously – assumed that such variations in skin colour and facial features were fundamental and highly significant, evidence of mankind's god-given and incontrovertible division into what we called 'races', a term that has no basis in fact.

The pattern of our spread around the world is becoming clearer as our DNA is traced. About 60,000 years ago we began to

occupy land outside Africa, gradually edging east along the coast around India, through Indonesia and down into Australia, and north through the Middle East, branching westwards into Europe and pushing up into the tundra, down from there into China, and finally over the Bering Strait (then a land bridge) into the Americas. There is greater DNA diversity between two groups of chimpanzees living in the same forest but separated by a river than there is among the whole human species spread across five continents. We are all one people.

We are, at the same time, all individuals, unique, self-centred and essentially alone. Our distinction is one of the greatest mysteries we face. At the same time we are all much more alike than we are unlike. Similarity and difference are both essential to life, the crucial building blocks of evolution. Without similarity, there could be no reproduction; without difference, no change. But there is no evidence to suggest that human beings have evolved any fundamental differences since we first emerged as a species only 100,000 or so years ago. Our environmental adaptations have produced merely superficial characteristics. Our minds don't appear to have altered over time. Everything suggests that we would be able to sympathise with the feelings and concerns of the earliest modern humans if we could learn their language and appreciate the commonsense assumptions that governed their thoughts.

One of the distinguishing traits of being human is that we can communicate with each other in profound, subtle and immensely complex ways. And we can achieve this level of communication not just with people living in our own time who share our own perceptions, but across centuries and cultures, with people who are now dead and lived in ages very foreign to our own. The main way we do this is through works of art that last longer than we do. When we look at a cave painting of a bull, a camel figurine from the Tang Dynasty or a Rembrandt self-portrait, we feel excitingly close

to the people of the distant past who created these wonderful things; we can easily imagine that we are looking over their shoulders as they work. This familiarity is not deceptive: the feeling we get is too warm and too strong. It only becomes a deception if we let this sense of fellow-feeling tempt us to assume that these ancient people shared our current world view. Our minds haven't changed but our thoughts have, and hugely. The forms of a body, a tree, a pyramid, an altar and a veil have flowered in our minds, one after the other, in an ongoing process of poetic insight, a slowly unfolding journey of realisation, and reflections of them still linger in our thoughts in our modern, scientific age.

Body

The evolution of modern humans is still mysterious largely because the evidence for this transformation is effectively non-existent. The aquatic ape theory that explains the apparent differences between modern humans and other hominids (such as our comparative hairlessness and dependency upon water) by claiming that we evolved independently from a swimming ancestor, perhaps even a dolphin, has been discredited. But the idea that *Homo sapiens* were more aquatic than other hominids in their earlier formative history is now gaining ground in scientific circles.

The first modern humans probably didn't live on the African savannas, as has been generally accepted, but were instead estuary dwellers who became highly adept at wading through the shallows in search of rich and arguably mentally stimulating food. Such a lifestyle could explain many traits common to human beings, such as our fondness for living near water and taking our children to play by the sea, and for their remarkable ability to balance on their par-

ents' shoulders – a necessary skill to develop if adults spent much of their time knee- or waist-deep hunting in water. All this is of course conjectural and likely to remain so, because any evidence there might have been relating to very early human activity in littoral habitats was lost at the end of the last Ice Age, a mere 12,000 years ago, when sea levels rose by approximately a hundred metres.

This cataclysmic event generated many myths concerning a great flood around the world. The most famous of these referred to in the Bible could have been caused specifically by the sudden and catastrophic inundation which created the Black Sea as recently as 8,000 years ago. The general rise in sea level after the Ice Age, however, could explain another curious, worldwide phenomenon. The archaeological evidence indicates that around 35,000 years ago human groups all around the world began, apparently independently but contemporaneously, to bury their dead in preparation for an afterlife and to make art. This is unlikely to have been caused by simultaneous evolution, still less by some unimaginable early form of global communication.

The more probable explanation is that people had been digging graves and creating images before this time, but on lower ground. The likelihood is that we were mythmakers from the very start and carried our myths with us wherever we went. 35,000 years ago doesn't mark the era when we started to make art and bury our dead, but merely when our numbers had expanded so greatly that we were obliged to do these things on comparatively inhospitable terrain that was high enough not to be lost in the subsequent inundation. The fact that virtually no traces survive of the first 80,000 or so years of human history, including our crucial emergence as a species, is the strongest evidence we have that we lived at first on the vast, extensive wetlands that are now beneath the sea.

The world which we humans first woke up to was glorious, miraculous and fecund, but also unpredictable and alarming. Our

ancestors found sustenance and shelter among the reeds and trees in river valleys, and by estuaries, with their daily banquets of shellfish stranded by the ebbing tide. The hills and mountains on the horizon were cloaked with impenetrable forests, filled with mystery and danger, and the dark ocean waves rolled away into the unfathomable distance. Overhead, the sun rose, burned and died, clouds loomed and dispersed, and vast flocks of birds flew off to unimaginable destinations. At each day's end, the blue dome melted into blood and the stars appeared, myriad fireflies piercing the dense blackness. The air resonated with a shifting kaleidoscope of noise: clamorous waves of bird calls signalling the dawn, the pounding of hooves on the grasslands, the roars and howls of ravening beasts, the steady drone and intermittent whine of insect swarms. Nature swathed us with familiar and frightening sights and sounds.

When they gazed at this world around them, how did the first people begin to work out how everything fitted together? On one level, this isn't such a difficult thing to imagine, because we have the same eyes and the same brains as they had: we are essentially the same people, subject to the same natural forces, with the same cycles punctuating our days and years. Although many people's lives today are submerged in cities, the larger planet we all inhabit is still composed of the same elements, the same sky and sea, earth, mountains and rivers. Wild flora and fauna haven't changed, where they survive in the tiny pockets of wilderness that remain.

Our earliest ancestors had no concept of the cosmos, let alone of geological time or evolution. But like us, they were curious, and eager to make sense of things. Their reasoning had to be logical, because they had to convince others, most pressingly their own children who continually pestered them with questions. They wanted to know where the sun came from at dawn and where it went at night, why the moon changed shape, how the tides rose and fell, what was at the bottom of the sea, where babies came from, and

what happened to people when they died. Our earliest world view was formed when we tried to explain these mysteries, and our conclusions could only be based on the self-evident truths of what we saw around us.

Our first world picture was of a living body, a great deal bigger than our own, obviously, but very like it. This body was bumpy and knobbly, as we were. Some areas were smooth and rounded, like pregnant bellies, buttocks and full breasts, others were pointed and upright, like fingers or erect penises. Soft soil covered hard rocks just as yielding flesh padded our bones. Blades of grass grew through the earth like the hair rooted in our skin. The ground had hollows and furrows, bushy clefts and hidden orifices, as we did. Some of these poured forth springs, in the same way that we discharged urine, but nature's water was clear and odourless, and beautiful to drink.

There was one thing that no one could doubt: the earth was alive. She gave birth to the plants and animals that sustained us. She dominated our lives like a splendid but temperamental mother, who could turn without warning from gentle and nurturing to harsh and uncaring. She often flew into a rage, wailing and spitting violent storms, and sometimes her whole body shook with fury. But on calm days, when she was resting or asleep, you could watch her breathing.

Water was always close to us, as essential as the air we breathed. But neither air nor water was our true domain – that much was clear. We didn't have wings and feathers, or fins and scales. We had hairy skins like the body of the earth. We walked on legs and our feet were wedded to the ground. When we waded out into lagoons and floated on our backs, at ease, well fed, in the sunshine, we must surely have compared our undulating bodies to the earth surrounded by water. And we must have observed that the water

lapping around us rose and fell as we breathed in and out. This explained a great mystery.

There was one fundamental truth about water: it always ran down, never up. Rain fell from the skies and disappeared into the ground. This water had to be going somewhere, and the logical destination was a vast underground sea. In all the oldest narratives that have come down to us – the Egyptian Book of the Dead, the Norse sagas and the Hindu scriptures – it was assumed that there was an ocean under the world, as well as lying all around it. The god of the Bible, in the Old Testament, commands his followers: 'Thou shalt not make unto thee any graven images, or any likeness of anything that is in heaven above, or that is on the earth beneath or that is in the water under the earth.'

The lowest hems on Chinese emperors' robes were always fringed with pearl-studded embroidery representing the waves of this subterranean sea. But if water could only flow downwards, what then caused the sea to rise, as it did, twice a day, with the tide? There could only be one logical explanation: it was the land that was moving, not the water. The earth was a gigantic body floating in a vast ocean, and like us it breathed in and out, regularly but much more slowly than we did, of course, because it was so much bigger.

There were various ideas about what form this living body took. The Muisca people of Colombia thought the world was a huge alligator lying motionless in the water, with a hard, spiked mountain range (the Andes) running in ridges along its back. For the Chinese and the Hindus in India, the earth was a monstrous turtle with a rock-encrusted shell, paddling in a bottomless ocean. This extraordinary creature swims in the sea, but ventures on to land to produce its young, when it lays eggs like a bird. A great turtle could surely be the mother of all creatures. In the ancient cultures around the Mediterranean, the living earth was a broad-chested, broad-shoul-

dered giant. To the people of Malta this figure was a man, but more generally it was thought to be a big-bosomed woman.

There was a very good reason for seeing the world as female: it gave birth. Fish were born in the sea; since they didn't have legs, they couldn't be born on land. Birds, whose home was in the sky, hatched from eggs domed like heaven. The eggs of the thrush, which sang so beautifully in the clear light of the morning, were a pure, unsullied, celestial blue; the ominous raven's were dark and cloudy like a coming storm, while those of the nocturnal owl were as white and round as the moon. Floating magically inside every egg was a round, golden sun, heralding the coming birth. The cock, with his beak held high above his dangling red wattle, crowed at sunrise, just as men awoke with proud, hot erections, ready to father a son.

The eminently sensible assumption that things that looked alike must *be* alike dominated human thinking for millennia, right up to the time of Renaissance thinkers such as Leonardo da Vinci. Mountain ranges seen on the horizon had the faces and bodies of sleeping giants, or the profiles of huge supine beasts, and people treated them with due respect, lest they should wake up and wreak havoc through the world. Our first medicine arose from sympathetic magic based on the similarity of appearances. Lightning struck like an attacking snake; both had tongues that forked and flickered. Snakes looked like aroused penises, but they spat poison, whereas penises spurted white, life-giving juices. White lightning was a magical mixture of poison and semen; it could burn a tree or kill a human being, but it also presaged life-giving rain. In cultures the world over, shamans performed healing dances with live snakes, to persuade the rains to fall, to cure diseases and to avert disaster.

If birds were born from the air, and fish from the sea, it naturally followed that creatures which walked on land had to be born from the earth. Up until the mid-nineteenth century it was widely

believed, even among scientists, that the earth's smallest creatures were spontaneously generated out of decaying matter. Maggots hatched out of rotting meat, giving birth to flies, and mice were generated out of grain stirred with dirty linen. Louis Pasteur finally disproved the theory of spontaneous generation in 1859. Before that, life was thought to originate from heat, for it was believed that the warmth of rotting compost had to have a purpose. In his great poem *On the Nature of the Universe*, the Roman philosopher Lucretius explained that 'in the childhood of the world, there was a great superfluity of heat and moisture in the soil, and there grew up wombs clinging to the earth by roots. When ripe, they burst open and the embryos of the first mammals, rejecting moisture, now struggled for air. Then nature made the earth open its veins and exude a juice resembling milk, just as nowadays the breast of every female who has given birth swells with sweet milk... so the name of mother has rightly been bestowed on the earth.'

Our ancestors must have recognised the similarity between the birth of their own kind and that of the deer and wild cattle which they were dependent on for food. And they knew that the earth itself had wombs, great hollow cavities underground. But then they became aware of a surprising and frightening ability: that human beings could give birth in a way which set them apart from all other creatures. They could use their hands to create images which looked alive. Taboos must rapidly have accrued to this strange, creative power of mankind.

The world's oldest-known paintings are in the caves of France and Spain; those in the Chauvet Cave in southern France date from about 32,000 years ago. Most of these paintings have been found by chance, preserved from damage and decay by rock falls which sealed in their secrets millennia ago; the entrances our ancestors would have used no longer survive. However, those at Font-de-Gaume and

Les Combarelles in the Périgord are exceptional in having retained their original cave mouths. Passing through these orifices is eerily like entering the eye socket of a skull, or walking down a throat past an uvula. Inside the cave passages, the bulging, slippery surfaces, stained red and glistening, resemble the walls of living internal organs, specifically an engorged, moist vagina.

The sophistication of prehistoric artistry is extraordinary – Picasso's dry comment, on visiting Lascaux, was, 'We've learnt nothing' – but what is even more remarkable is what they didn't paint. They clearly had the skills to draw anything – trees, flowers, rivers, mountains, clouds, human faces – but the significant fact is that they chose not to. Virtually the only representational images on cave walls and ceilings are of animals, almost all of them the beasts that roamed and grazed the nearby pastures. Depictions of humans are extremely rare, and the isolated drawings of fish and birds that have been found are nearly all of questionable date. The reason was straightforward: image-making was an act of giving birth, and art made in caves was reserved for animals that were born from the earth. The fact that we did not depict ourselves in caves suggests that we did not consider ourselves to be the same as animals, nor were we born from the earth. We did not need this ritual enactment to help us create.

Cave paintings are rarely found on flat surfaces; they generally follow the natural curves and swelling forms of the rock wall. The man-made outlines seem to be helping animals to appear that were already there, latent presences inside the rock. The artist has stroked them into emerging in the same tender, loving but firm way that a midwife eases out a baby's head. One sinuous contour can be enough to evoke the rhythm of a strolling mammoth, the charge of a rhinoceros or the stealthy prowl of a lion, superbly economical summations of creatures in movement. These artists didn't need to

copy from a model or a sketch; they were so familiar with their sub-jects that they could conjure them up perfectly in their mind's eye. The act of imagining, of dreaming into existence, might have been part of the magical process of bringing to life. The painters knew these animals in intimate detail; some of the red deer in Lascaux, for example, are depicted with the pre-orbital glands in front of their eyes in a dilated state, something which only occurs when the animal is roaring during the rut, under stress, or suckling as a calf.

What was caught in these caves was the spirit of movement specific to an animal, the essence of its life. The artists went on draw-ing one animal on top of another, for a sacred womb can give birth to many animals, just as a woman can give birth to many children. Though we today can't help searching for compositions in the bewil-dering meshes of overlapping lines, these images were never intended to be pictures in our sense of the word. Painting was an aid to creation. Making the image was what mattered, not viewing it afterwards. These people felt that they needed to help the earth give birth. Depictions of the cattle and deer that they killed to eat could have been made in a spirit of thanksgiving and to ensure a continuing supply. Paintings of animals that were not killed for food, such as lions and rhinoceros, were possibly made as an act of hom-age to ancestors, perhaps as part of an initiation ritual if killing such a beast was something a youth had to do to enter adulthood.

Many of these works of art are not just superb demonstra-tions of abstraction but extraordinary for their emotional charge. They are simultaneously hymns of praise and cries of loss. The feel-ings of joy and sadness in them are too powerful and unsentimental to be merely back-projected emotions of our own. This must have been intended by the people who made them: direct, instinctive expressions of the love and suffering they felt in their hearts. There is no reason to think that our ancestors didn't regret the deaths of

the beautiful creatures they loved, even if they killed these animals themselves.

The breath of life was sacred. Many paintings and engravings have parallel lines drawn from their nostrils which indicate that they are breathing. These depictions look so alive that you hold your breath when you see them, as you do instinctively when you see an animal near you in the wild. Painted caves were about the mysteries of life and death. Navajo hunters in North America used to chase a deer all day till it eventually collapsed from exhaustion. If the meat was to be used in a religious ceremony, before strangling the deer, the hunter would hold a little sacred pollen to its mouth to ensure that its last breath was holy. Perhaps similar rituals were performed by the people who lived and hunted across the hills in France as they re-enacted their beliefs in the caves below.

When people lived in places that didn't have caves, they built them. The oldest town so far discovered, Çatalhöyük in southern Anatolia, was a mound of man-made caves built on a patch of dry land in what was once an extensive, fertile wetland. It housed a population of several thousand and was occupied from about 7,500 to 6,000 BCE. Though this was thousands of years after the era of the cave painters, in many ways it represented a continuation of their beliefs. The houses followed the same pattern: they were all window-less, walled rectangles with a few internal partitions, each with an entrance through a small hole in the roof accessed by means of a removable wooden ladder. There were obviously security reasons for this arrangement, but it must also have been symbolic.

The cave-like rooms below, dimly lit by lamps and fires, served as homes and hearths, wombs and tombs. This was where the inhabitants stored and prepared their food, ate, slept, gave birth and died, and buried select members of their families beneath the floors. Some of the walls were encrusted with animal skulls, horns

and antlers, and both these and the walls were regularly re-plastered. They painted pictures on the walls of leopards and vultures, and larger scenes showing men wearing leopard-skin loincloths baiting gigantic bulls and boars. These paintings were probably executed in rites celebrating a birth, initiation, marriage or death, but quite soon afterwards they too were covered with white plaster. In one burial a human skull was found with its face remodelled in plaster, similar to skulls found in the walls of the slightly later city of Jericho. For these people, pure white clay was a living substance, the flesh of the earth. Painting and plastering were not decorating but ways of giving birth and being reborn after death.

In all the early societies whose practices survived into the modern age, the business of image-making was strictly controlled, and almost invariably restricted to men. Women were permitted to make abstract patterns, on pots, cloths and baskets, but figurative art was a solely male domain. The logic was that if a woman made an image, its spirit could interfere with the children she bore. Recent research, however, suggests that more women went down into painted caves than men. A study of the sprayed outlines of hands that often accompanied these paintings has shown that three quarters of them belonged to women. (Women's first and third fingers are of approximately equal length, whereas men's third fingers are generally longer than their first.) The act of placing your hand on the surface of a sacred rock and sealing its touch with a spray of blood-coloured breath could have been part of a healing process, or a blessing connected with bearing a child, though that does not necessarily mean that the sprayed hands were the ones that painted the pictures themselves. They were the hands of those who benefited from the living rock.

Encouraging the earth to give birth might have started as a communal enterprise, like the large Dreamtime paintings of tradi-

tional Australian Aborigines, which women today still contribute to, though almost invariably under a headman's supervision. What is certain is that, over time, the making of figurative art became a solely male concern (as it continued to be until our modern age). Images unleashed powers: painted hands could fight; painted teeth could bite; a painted penis could impregnate; a painted womb could give birth. But, most frightening of all, painted eyes could see.

For people in the past, sight was a beam of light sent out from the eyes which actually touched what it saw, just as the fingers of a baby reach out to feel anything that catches its attention. Even though we now know that no rays are actually being emitted, it's hard for most of us to throw off the idea that looks can kill, that eyes in themselves can be evil. From our earliest days we knew that seeing and hearing were tools which we could sharpen, as we could hone an antler pick or knap the flint tip of an arrow. As hunters, we learned to focus our sight and concentrate our hearing over considerable distances.

We knew that light shone out of our eyes. This light wasn't as strong as a flaming torch, nor anything like as powerful as the sun, but it could light up the world around us. The tents, huts and mud-and-wattle homes in which we and our families sheltered from the elements had windowless, gloomy interiors, but after a time inside, the power of our eyes lit up everything quite clearly. This put anyone inside at a considerable advantage over a potentially unwelcome intruder who would at first be blinded in the gloom. We liked sitting in the dark because we could see by our own light. Sight was an innate faculty, the surest sign of life itself.

All of our oldest beliefs were centred, sensibly, around seeing, as Hinduism, the most ancient surviving religion, still is. In Hindu worship, which is essentially participating in a love affair with the gods, all the senses are harnessed, but the most important is that

of vision – the strongest sense for those in love, for whom any time spent out of sight of their sweetheart is an agony of unfulfilment. Unlike the followers of all the other major religions, Hindus pray with their eyes open. Darsan, the high point of Hindu worship, is the moment when worshippers gaze into the eyes of their god who gazes back, in an unforgettable moment of eye contact, with love flowing between divinity and humanity and bathing the world in life-giving glory. Belief in the Evil Eye is still widespread around the world, but belief in the Beneficent Eye survives only in Hinduism.

Making visible was crucial to our earliest religions, the faith that was made manifest in the painted caves of Spain and France. When in 1879 the amateur archaeologist Marcelino Sanz de Sautuola went to investigate the Altamira caves, he took his young daughter Maria with him. While he was excavating the cave floor for traces of early man, the little girl wandered around, keeping her eyes open. Suddenly she shouted, 'Look, papa, oxen!' Her father raised his head and was amazed to see vivid paintings of bison on the ceiling. He published his findings shortly afterwards, claiming them to be from the Stone Age, but was dismissed as naive or, worse, a fraud. It was then generally accepted that the history of humanity had been a more or less continuous path of advancement, and these paintings were much too sophisticated to have been made in such a primitive era. We were looking back at and down on the past and, like Don Marcelino, it hadn't occurred to us to look up.

The decision to paint on cave ceilings was certainly signifi-cant. Perhaps it was believed that the earth dropped its newborn, as foals and calves drop from the womb of the mare and the cow. But it could also be that people thought larger animals had one par-ent in the earth and another in the stars. Their graceful profiles could be traced as constellations – a celestial horse, bear, bull, lion, goat

or snake – an early instance of joining up the dots, a game which still appeals to the pattern-finding propensity of our minds. These star-studded contours still haunt our collective imagination, notably in the signs of the zodiac, which are common to most cultures around the world, with remarkably few variations. But if it was true that certain animals had their origins in the sky, we needed an explanation of how they had come down to earth. Flames always rose; they never fell. The sparks of life were surely governed by the same natural law.

Hominids had mastered fire at least one and a half million years before the emergence of *Homo sapiens sapiens*. Familiar and indeed vital though it was to early man, fire must still have appeared magical to our minds. Mysteriously, fire had no home on earth. As soon as it was freed from the flints or dry twigs in which it was trapped, it leapt up and away. Fire was the opposite of water. Both were fluid and semi-transparent, but flames were red and yellow, hot and bright, while water was green-blue, cold and dark. Fire always rose, as men rose hot and light when they were young and full of passion, and their blood was up. Water always fell; it was heavy, like the limbs of men grown old, whose blood, when they died, ran cold.

When you threw water on fire, the two elements clashed and vanished in a hiss of mist. The wonder was that the heat and colour of fire and the cold fluidity of water could be combined within the fur cladding of animals and the skins of men, to create a flowing, warm, red liquid that was unlike any other substance on earth. Blood mingled the eternal, opposing forces of the world. The most significant offering you could make to a spirit you wanted to appease was the sacrifice of a warm-blooded animal or, in times of utter desperation, a human being. The practice of blood sacrifices was widespread for most faiths around the world until around two thousand

years ago. This wasn't bloodthirstiness in our sense of the word: for our ancestors, blood was the liquid gift of life that, *in extremis*, could be offered back to a greater being, the original ancestor that had first given us life.

Fire emitted light, and light, like fire, had no home on earth. There were exceptions, such as the ghostly luminescence given off by fireflies, glow-worms and phosphorescence, but it was as cold and inconstant as the moon, not like the warm, life-giving light that came from the sun. The few who lived within sight of a volcano must have imagined demonic spirits living deep under the earth to explain such a terrifying marvel. But for most people, warming themselves by the fire at night, the wonder was where the sparks went to as they floated up and disappeared into the starlight above. Light, clearly, was essential to life. You only had to look at the spark of light in your kinsman's eye, the spark of life that went out when you died.

As night fell a vast array of tiny lights began to shine above our heads: the stars. They were so bright and twinkling we thought that they must be alive. They couldn't be the fiery embers that rose into the sky because, as we watched those, we saw them die, whereas the stars went on shining as if forever. We traced patterns in their configurations and believed we could see the spirit ancestors of the beasts that roamed around us. But, most of all, we saw ourselves in these myriad fiery essences. It made sense to see them as the sparks of life of people who had died or were waiting to be born, hovering in the darkness that surrounded the sunlit daytime of our brief existence.

The stars had another attribute (invisible today through our polluted skies): they were rainbow-hued, like dew drops in the first light of morning. Some stars shone blue or green. These might be our fathers and mothers and more distant ancestors, spirits that

had gone before us and were now dim and cold. Those traditional Aborigines who still live under unpolluted, multicoloured night skies habitually avert their gaze when they see a shooting star: it's unlucky to witness a dying spirit. For we believed even stars could die and some could be born. The stars that glowed white, gold and red were clearly warming with new life. They could be our children and the generations after them, waiting to descend to earth. Did we draw these sparks of light down to us when we looked into our beloved's eyes? There had to be a reason why we were the only creatures that made love facing each other, while the lights in our eyes mingled, tempting down the stars.

When day came, the stars disappeared and the sky looked like the inside shell of a blue-domed egg. Unlike any other creature, we were born with heads which were egg-shaped, like the sky. From earliest times we must have realised that there was something special about this dome. Still today, Chinese mothers ensure that their babies' skulls reflect the shape of the sky by carefully turning the sleeping infant's head, which is placed on a pillow filled with rice or beans. And we still call the sides of our brows our 'temples' – elevated homes for spirits. The conclusion we came to, looking around us, was that the sky was the head of the great being whose body was the earth. And like every head, it had two eyes.

The sun and the moon were the twin eyes of heaven, the lights of the world. We now know that it's an extraordinary coincidence that these two heavenly bodies appear to be the same size when viewed from earth. Countless millions of human lives have been affected by this cosmic fluke. To our ancestors this similarity in circumference of the sun and moon made their differences all the more remarkable, and these confirmed everything they then understood about their world. All living creatures came in pairs, one of each gender, and the sun and moon, which were no less alive, clearly corresponded to male and female characteristics. The moon's rays

were soft, gentle and feminine, in contrast to the sun's, which were fierce, strong and masculine. The sun was constant, unchanging and unyielding. The moon was fickle, and sometimes sickle – the only celestial body which changed shape.

The moon became pregnant every month. Around the world it used to be widely believed that women were at their most fertile at the time of the full moon. The emperor of China made love only to his primary queen, the empress, on such nights. Discreetly hidden scribes made careful records of his ejaculations, for the Chinese, strictly logical as ever, calculated horoscopes and ages (as they still do) from the moment of conception, not birth. Our ancestors' survival depended on their keeping track of the rhythms of nature, and the link between the changing moon and the menstrual cycle of women must have been observed from very early times. Naturally, the milk that swelled the breasts of pregnant women was white, like the light of the moon. Everything fitted.

The sexes seem to have been divided into hunters or gatherers from earliest times. Men still like to walk unencumbered, with their arms free, prepared to fight or chase, while women carry bags, ready to pick and collect – the gender difference can be seen on any city street. But the contrasts between the sun and the moon suggested an interpretation of the innate differences between men and women which has blighted human relationships for most of our history. It was assumed that men were born higher than women and had authority over them. The moon came to be associated with all things intimate and motherly – fecundity, tenderness, romance and sex – while the much more powerful sun was seen to represent the warrior, hunter and king, confirming the belief that the greater strength of the male legitimised his superiority. The sun was in charge of the day, and the serious business of the state; the moon ruled the night, the domestic and the private – and this became the assumed pattern in most societies until modern times.

The theory that the human body is made up of four distinct cold, wet, dry and hot substances, or 'humours', was first codified by the Hippocratic writers in Ancient Greece, but it stems from much earlier ideas, derived from the essential attributes of the sun and moon and the properties of fire and water. In tribal societies which survived into modern times, men were responsible for carving stones and making fire; modelling cold, wet clay was women's work. Only women gathered round wells, and even today in rural India collecting water is an exclusively female task. Men, traditionally, sat and talked under trees. Penises grew hard; vaginas became succulent. Men were sons of the strong, unchanging sun, women daughters of the watery, inconstant moon.

An even greater mystery was the daily birth and death of the sun, a continual reminder of our own mortality. Before modern times, the tolling of a church or temple bell was the loudest man-made sound most people ever heard during their everyday lives, reverberating into the surrounding silence, when the horns of war did not disrupt the peace. Bells rang out not just when people were born, married and died, or when prayers had to be offered to the gods, but every day, at dawn, midday and sunset. In Catholic countries the evening Angelus bell rang as the sun sank beneath the horizon, and until recent times people everywhere, in fields and cities, would down their tools, bow their heads and pray for their souls and those of the departed. In 1859, J. F. Millet, the son of a farmer, celebrated this moment in a painting of peasants praying which became one of the most popular reproductions of the nineteenth century, just as this tradition was fading. At sunset, silence fell across the world. The sun was dying, as everything had to die, in a bath of blood.

The great wonder was that it was reborn every morning. The whole of nature rejoiced, in a dawn chorus now inaudible to or

ignored by most of the world's population. Sunrise and sunset cer-
emonies were performed daily in most societies across the world, as
they still are in India. The city of Varanasi initially grew up at an
east–west crossing point on the river Ganges, already, by that point,
very wide. Priests still perform fire-beacon ceremonies standing on
the river bank every morning and evening, celebrating the rising
and setting sun. Many of these dawn and dusk celebrations were
solitary, private acts of praise. An early twentieth-century photo-
graph by the American Edward Curtis records a young Lakota brave
holding up two eagle feathers to greet the rising sun, as he chants a
tribal hymn: 'Here am I. Behold me. I am the sun. Behold me.' This
was not arrogant presumption, but humble recognition: the power
of the sun recharged every man.

At the same time, everyone knew that the sun was infinitely
stronger than them – no one could look at it for more than an
instant. The peoples of the Americas, both North and South,
believed that only eagles could gaze into the eye of sun, for they
could fly higher and see further than any other creature. In many
ancient cultures corpses were exposed on high platforms so that
eagles and vultures would eat their flesh, thereby helping to raise
their spirits to the stars. All over the world, burials were aligned
along the course of the sun, on an east–west axis. Bodies were often
sprinkled with red ochre, around their heads in particular. Although
it is usually thought that this earth pigment represented blood, the
powder was never confined to the body alone – it was spread liber-
ally, like a cloud, in expression of a more universal grief and a larger
hope. The red stain symbolised the sunset of a life, together with the
promise that life would be reborn.

Another intriguing characteristic of the sun was that it
changed its position in the sky throughout the year. Across the
northern hemisphere, where the majority of early humans lived, it

rose higher and hotter in summer, and lower in winter, when it was weaker. A cycle of birth, growth, fecundity and death governed our lives and our everyday concerns. But one thing heartened us: winter always gave way to spring. The implication was that mankind, and the whole of creation, would be reborn, and the birth of the coming year was celebrated in every culture around the world. The exact date varied, but it was always after deep midwinter and before the first full burst of spring. The seasons magically reflected the ages of man: spring was bright, fresh-faced youth, summer the prime of life and parenthood, autumn ripe maturity and winter old age, when hair turned white as snow. The earth was alive, as we were: we lived in a living body.

One of the earliest known carved images is of a female figurine fashioned in limestone, discovered in 1908 in clay deposits near the town of Willendorf in Austria. Unusually, it wasn't associated with a burial. It is generally dated to around 30,000 years ago, though some experts judge it to be only half as old. This little sculpture has come to be known as the Venus of Willendorf, a name which is seriously misleading. Venus was a sexy goddess, from a much later and very different time, named by the Romans after the planet that appeared as the Evening Star. The Willendorf woman is a dumpy little female, not a grand Roman beauty. She has broad shoulders, bulging breasts, billowing hips, a pronounced 'mound of Venus' with an ample cleat, big, ballooning buttocks and tiny feet. If she was wearing just a little more, you could imagine her tottering along in any modern shopping mall.

In book illustrations, the Venus of Willendorf looks monumental, but when you see her, in her vitrine in Vienna's Natural History Museum, you realise she's so tiny that you could easily cup her in the palm of your hand. Her smallness makes her grossness seem tender. This feeling is as unnerving as it is surprising – as it was

surely meant to be. From earliest times we must have been interested in our ability to imagine vastness in minuteness. Human beings have an extraordinary mental agility, as the poet William Blake recognised: we can 'see a world in a grain of sand, and a heaven in a wild flower'. This little sculpture surely symbolises something a great deal bigger than herself.

Intriguingly, the Willendorf figurine has no obvious use. There is no hole to indicate that she was an amulet or talisman intended to be threaded on a necklace or bracelet, or sewn on to a garment. Nor could she have stood upright on her tiny toes. She wasn't a goddess destined for an altar, still less an ornament to be propped up on some Stone Age mantelpiece or occasional table. It appears that she was made to be held in the hand, to be fondled and pondered. Her strangest aspect is that she has no face. Instead of a head, her plump figure is crowned with a round knob wreathed with patterned rings. These have been variously interpreted as coils of plaited hair, a knitted or woven bonnet, bands of scarification or ritual tattoos, though why such things would completely cover her facial features has never been satisfactorily explained.

But she must have had a meaning. She's too tenderly carved to be a trifle, or a sick joke of a woman gagged and blindfolded to be exploited by men. The probability is that she was made to be touched gingerly by pubescent hands, to initiate new generations into the secret meaning of life, not just sex but the whole business of birth and death, night and day, how the mountains, rivers and seas fitted together: all the answers, finally, to their childish 'whys'. The Willendorf figure was the universe. The novices felt her shoulders, breasts and hips, and knew they were the hills and valleys that they lived and walked among. Her feet were insignificant because, as everyone knew, the earth wasn't going anywhere, except perhaps paddling to keep afloat and upright and stay where she was in the

vast ocean. As for the round, eyeless ball on her shoulders, it represented just what it looked like: the stars slowly rotating in the dome of heaven that sat above the body of the earth.

The nightly progression of the stars is a phenomenon that is no longer commonly observed, hidden as it is from our eyes by light pollution, and from our thoughts by the knowledge that it's our planet that's spinning, not the heavens. But even with our modern understanding, it's still a remarkable experience to go out on a clear night and observe the easily recognised Great Bear or Plough (or Ladle, as it's known in China, or Big Dipper, as it's known in America). Initially, it might be half-hidden by treetops to the north but then, if you look again a few hours later, you see that the whole, vast constellation has swivelled round to the open skies in the south. What is even more extraordinary is that, in the meantime, the North Star – easily found by following the two 'pointer' stars in the Great Bear – hasn't moved at all. The whole starry firmament is revolving, anti-clockwise, around a single shining light.

A number of stone figurines similar in age and form to the Venus of Willendorf have been found in locations scattered across Eurasia. They have been variously interpreted as fertility charms or images of a primal Mother Goddess. What is most interesting is that many of them have no indication of a head, let alone facial features. Instead, they are topped off with an extended stump or a diminutive knob, which could have served as a pivot for a detachable 'head', perhaps made of a different material. This sphere, carved or painted with stars, would then have been rotated in imitation of the nightly circumambulation of the heavens.

A group of much later headless female figurines dating from the sixth millennium BCE have been found in several sites in Anatolia. One of the most discussed, the fired clay statuette known as the Seated Woman of Çatalhöyük, depicts a female figure of very

ample proportions seated on a throne flanked by two leopards. She was lacking a head when found in 1961, though she has now been given a spurious one by archaeological conservators. Surely these Neolithic 'mother goddesses' are better interpreted as images of the world, which would have had the circling heavens as heads. Then the two leopards on either side of the Woman of Çatalhöyük would make sense as the morning and the evening sun. The mysterious late Neolithic petrospheres, intricately carved and studded stone balls found mainly in north-east Scotland, which have no apparent function, could, similarly, have been sacred images of the rotating heavens, rosaries in the round to help people say prayers in desperate times.

The spiritual life of the extremely ancient Ainu people of the Japanese island of Hokkaido was governed by women shamans who, when in a deep, meditative trance, saw their ancestors flickering around their heads like stars. The Venus of Willendorf held within her the power of the whole world, the cosmic being that had given us birth and to which we all return; the source of life, the spirit of everything, the relationship between the earth and stars. She represents our first world view, our perception of the universe as a living body, and she still lingers, wistfully, in our thoughts whenever we speak, unthinkingly, of Mother Nature.

Tree

When it was first practised, the cultivation of crops must have been a highly contentious activity. It wasn't simply a matter of technological advances in the provision of food, using spades instead of spears: it was the manifestation of a radical change in how people saw their world. Traditionalists in the tribe surely warned that no good would come of it. Treating the living earth with such disrespect, digging into her skin, clearing away her bones, was bound to bring retribution on the people's heads. And these arguments must have hit home, for any child would be traumatised by seeing its mother's body scarred, bruised and wounded. However, it must have been very tempting to develop a securer way of ensuring a reliable and adequate food supply for our expanding communities. The agricultural revolution made life harder initially, though ultimately it delivered cities and unimaginable technological advances.

Wheat and barley were first cultivated about 10,000 years ago in the Near East, though wild cereal grasses had supplemented

our diet long before that. Grass was what deer and wild cattle fed on, and for millennia their meat was central to our survival. Then people discovered that they could domesticate animals and that the ears of some grasses could be ground to make meal and flour, which they mixed with water and cooked to make gruel or bread. Grass could feed them as well as their animals. And they found that they could sow a seed and it would grow into a blade of grass which would itself, in time, form many new seeds. This led to a dramatic change in our understanding of the world: the seed was alive in a way that the earth wasn't. Grass wasn't like hair sprouting out of living flesh; it had a separate existence, a thread of life curled up within a tiny grain. New life sprung from old life, not out of the ground.

Hunting and gathering continued alongside farming, but more and more of people's time came to be spent on new types of labour: sowing and harvesting, threshing, winnowing and grinding. As they ploughed, planted, reaped and milled, and contemplated the universe from their fields and pastures, a new reality began to emerge: the living world was not a single, indivisible entity. The earth ceased to be a warm, encompassing presence, a mother who embraced, protected and fed us, and punished us when we misbehaved. Life turned into a tree living within the universe.

Our hold on life had become firmer, but at the same time more tenuous. We could manage our food supply, but we also realised how easily the supply line could be broken, especially when, as often happened, the harvest failed. Our new conception saw the threads of life branching out and extending to link all living things, in a mass of interconnecting filaments. Clearly, the world had a life force running through it on which we were utterly dependent, but whose extent and nature we were only just beginning to chart and harness to our needs. This life force didn't flow like a river, whose waters invariably ran downwards to darkness and death; it shot up like a seed, growing towards light and life.

Trees must have haunted the human imagination from earliest times. They were by far the largest, tallest and oldest living things. Their massive trunks expressed strength, longevity and rectitude; they were noble and generous, sheltering all who came under their spreading branches. Trees changed with the seasons, as we did in the course of our brief lives, bursting with fresh green energy in springtime, then flowering, fruiting, mellowing and finally growing dry and barren. But the winter of their lives was not the end, as it was for us; they came to life again in spring. They had seen our ancestors and they would see our descendants. Trees were centred, symmetrical and immobile, like the universe.

Our first image of the world as an ample body crowned with a cosmic sphere was gradually pared down and stripped of its flesh, until all that was left were the branching blood vessels in its core. The World Tree was an immense central life force whose roots reached down to the waters under the earth, and whose topmost branches brushed the clouds and the starry vault above. It spread its tentacles into every living thing. You could trace these in the veins on the back of your hand and see them splayed across every leaf. The tiny seed had the tree hidden within it; the small contained the great. A single leaf, stood upright on its stem, formed a little profile of the tree as a whole. A newborn baby was wondrously mankind in miniature, as every parent knew, complete with minuscule eyelashes, fingernails and toes. We were linked to the tree of life.

Trees stood erect as we humans did, alone among the four-legged animals of the earth. The largest and oldest, like the oak, were crowned with dome-like skulls, as we were, which echoed the shape of the sky. Sap ran through the bodies of trees like blood, and they bled if their bark was cut. And the pillar at the centre of their being, the firm, straight trunk, resembled the one essential organ without which human life could not continue: the erect penis that pushed

upright from its scraggy undergrowth and seeded future generations, as trees spread forth their branches. The image of a World Tree reinforced the concept of the dominion of the male. Women were relegated to a lower, receptive status: they were the hills, valleys and lakes, still half-submerged in older beliefs in Mother Nature. Men stood proud, not only stronger and harder, a trunk to lean on, but taller and therefore more far-seeing. The soil had given birth to sons, as the earth gave birth daily to the sun.

For most of our history, until very recently, the chief priority of mankind has been reproduction. Male sexual prowess was something to be proud of, celebrated throughout history in phallic symbols which were often as blatant as Henry VIII's thrusting codpiece, daintily decorated with coloured bows. Maypoles used to be common sights on English village greens, and pubescent girls and boys holding ribbons would dance around them every spring in what began as a flagrantly erotic ritual, celebrating the fecund trunk at the heart of the world. In Italy, a recently rediscovered thirteenth-century fresco in the Tuscan town of Massa Marittima, painted on a wall above the town well, shows a great tree fruiting with penises and testicles, with a group of women underneath plucking them and arguing over their harvest.

The phallus was a symbol of possession, in every sense. The Roman god of fertility, Priapus, was also the protector of property; his attribute, an erect penis, painted bright red, perched jauntily above doorways in Pompeii. The ancient Giant of Cerne Abbas, a huge drawing cut into a chalk hillside in southern England, brandishes both a cudgel and a colossal erection. He probably marked the boundary of a tribal territory. In Japan, from early times up until the twentieth century, standing stones carved in the shape of erect penises commonly stood at forks in roads, as they stand in the fork of man.

The World Tree held within it an urgent potency, a concentration of the furious drive that made all male creatures fight to mate. The trunk which rose at its centre spiralled like the maypole, growing as most trees do in a gradual twist. This echoed the nightly rotation of the constellations around what is still today referred to as the Pole Star. The Hindu Vedas describe the churning column which stands in the middle of the universe, the vibrant vortex that is the origin of all creation. Action and substance erupted out of the stillness and emptiness at the beginning of time; life acquired form from the agitation of the cosmos, just as solid butter is churned from liquid milk. The pole used to stir it into life was Mount Mandara, which grew out of the back of Kurma, the Great Turtle that represented the earth floating on the subterranean ocean. Vasuki, the Serpent King, kindly supplied his body for use as a churning rope.

The great twelfth-century temple of Angkor Wat in Cambodia celebrates this churning of the primal ocean and the subsequent burgeoning of all creation in a gloriously playful frieze, the longest in the world, which would originally have been painted in resplendent jungle colours. Its balustrades are in the form of stone cobras, which celebrate the world's birth at the same time as warning the uninitiated not to enter. When cobras mate, they lock together in a spiral, a single, rising, writhing trunk, eternally replaying the origin of the universe. Curiously enough, this formation echoes the double helix structure of DNA, the molecule now known to be the key to all living organisms. With what might seem natural justice, Angkor Wat and its adjacent temple cities were reclaimed for centuries by the jungle, buried under twisting roots and branches.

The immensity of the World Tree was impossible to paint or carve in its entirety. Some idea of the place it had in people's thoughts can be gauged from the riotously vibrant towers in Hindu temples in India, which are still regularly repainted, not just to keep their colours fresh, but as a sacred re-enactment of the continuous

rebirth of all living things. The great gateway towers in the Mee-nakshi Amman Temple in Madurai, Tamil Nadu, face the four directions within its square, sacred walled space that represents the extent of the flat world. Hinduism is one of the world's oldest faiths, much too ancient to have a named founder or a single authoritative sacred text, and many elements of mankind's earliest world pictures are reflected within its rites and beliefs. Still today, the ground chosen to site a new Hindu temple has to be seeded first to ensure that the soil is fertile. Like a tree, the temple has to grow from the earth. A ceremony then invites the spirits which are already living there to find another home. When they have graciously departed, building can begin.

The towers which dominate Hindu temples symbolise the vital growth rising upwards in the heart of the universe. Their summits are often topped with a cogged stone wheel which represents the circling stars – a vestigial memory of the Venus of Willendorf's celestial head. At the tower's base, always facing east, is a narrow, vaginal passage, which leads into a dark, cramped inner sanctuary directly beneath the temple's apex. Here sits the god, usually a simple, unadorned carving of the lingam, an erect penis, thrusting up through the yoni, a splayed, open vulva. The lingam represents the massive, snow-capped Mount Kailash, Lord Shiva's home in the Himalayas, and the yoni the lake that lies at its base, in which the snowy, semen-spilling peak is reflected. This lake symbolises Parvati, Shiva's beautiful, receptive consort. Our earliest world views morph from one into another, the living body of the world transformed into a phallic tree trunk which spawns all creation.

Vivid images of the World Tree survive in totem poles, carved out of single trunks of red cedar by the native peoples of north-west America who lived in the vast forest which hugged the Pacific coast. The Tlingit and Haida tribes believed that their spirits had inhabited the bodies of whales, bears and ravens in past lives. These creatures

perched, with great all-seeing eyes, at the top of the high poles which stood in front of their log houses, declaiming the ancestry of those who lived within. Up and down the poles crawled all manner of strange, contorted beings, their beaks and mouths wide open, swallowing bodies and giving birth. Humans and animals were linked together and changed places on the tree of life.

Transformation was a natural physical phenomenon in early cultures. A Tlingit dancer pulling the hidden strings in the huge mask on his head turned from an eagle into an orca whale before finally emerging as a man. In Ancient Greece, an unwary traveller lost in a forest might emerge, translated by some Puckish sprite, as a centaur, Pegasus or Pan. The Hindu deity Ganesha, the god of beginnings, is a human with an elephant's head. The branches of life which spread from the World Tree threaded through all creation. This was the era in human history when people were carried across the waves by dolphins, borne aloft by eagles and suckled in the woods by wolves.

The thread of life was sustained by eating and by giving birth. Once upon a time, the soil had drunk the rain, the sea had swallowed the rivers, and every night the earth had eaten the sun, only to give birth to it again at dawn. But now, no one could live from the earth alone; they had to eat the seed of the grass that grew in the earth, or the flesh of the cattle that ate the grass. Life had to die in order that life could live; this was a profound mystery. In carvings, patterns and designs, creatures are shown eating and being eaten, their jaws gaping wide to swallow another beast's tail. Tongues, tails and penises, mouths, anuses and vaginas all possessed similarities that had to have meaning.

An impish, mutating thread winds its way mischievously along the margins of medieval manuscripts and around the capitals in Romanesque churches, scatological vestiges of much older belief

systems in which the phenomena of resurrection and rebirth were attributes of all living things rather than the prerogative of one single, dominant Christian deity. The same thread emerges from the mouth of the Green Man, with his jaws gaping wide to spew out sprays of leaves. This vegetative head, whose presence is found in ancient cultures around the world, made a late appearance in sixteenth-century Italy, in the faces which the painter Arcimboldo created from fruit, flowers, fish and all manner of vegetables. Trees in the forest could see and hear, so they had to have eyes and ears. Exceptionally ancient trees were worshipped wherever they were found, and from Africa to India, America to Japan, little shrines are still found nestling in the crotches formed by their roots, decorated with offerings of flowers, lit lamps and treasured stones.

Trees were central to the imagery of the Maya people who lived in the forests of Central America centuries before the Spanish invasion. One of their greatest kings, Pakal II, was buried under a slab engraved with an image of a many-branched cosmic tree springing from his loins. His face was covered with a mask made from jade, which looked like sap turned to stone, the blood of the tree of life made immortal. For the Maya, stalactites growing down from the roofs of caves were the roots of the World Tree turned to stone, and huge ones were carefully cut and transported great distances and erected upright, their potency revived, in the very centre of their temples. At the moment when the sun shone directly down on it so that the stalactite cast no shadow, and the life-giving heat could be felt through its whole length, the signal was given for the Mayan ball game to begin.

No detailed descriptions of this ritualistic sport survive, though the courts on which it was played, complete with viewers' stands, were major features in almost all Mayan temples. It appears to have involved two teams of warriors keeping a heavy ball in the

air without using their hands, with the aim of dropping it through a stone ring high on the wall of the ballcourt. The pattern and duration of play are thought to have served as an elaborate form of fortune-telling, indicating what ceremonies and sacrifices had to be performed to ensure successful hunts, wars, marriages and harvests. It may also have been played as a way of resolving disputes without battles. The ancient, balletic Chinese game Ti Jian Zi, which is still popular today, might share a common ancestry: it too requires players to keep a weighted ball – here stuck with four feathers, symbolising the cardinal directions – in the air for as long as possible. The mystery of how the heavenly bodies stayed in the sky had to be related to the challenge everyone faced in sustaining the thread of life.

Among the remarkable artefacts found at the archaeological site of Sanxingdui in south-west China is a bronze tree some four metres tall, dating from the twelfth century BCE. At its top perches a fabulous bird, perhaps a phoenix, and its twisting roots are in the form of serpentine dragons. This image is close to that of Yggdrasil, the World Tree, which only survives in verbal descriptions in the ancient Norse sagas.

Yggdrasil's branches reached up to the sky, where eagles lived; its roots wriggled down into the underworld where they were transformed into the serpents of the deep. The Norns were beautiful, seductive, full-breasted female spirits who kept the tree watered so that its leaves never fell, thus accounting for the phenomenon of northern evergreens. Four great stags browsed upon these leaves, absorbing and distributing their beneficence to the corners of the world.

Stags were the kings of the forest, for they carried branches on their heads. Antlers sprout anew every year in spring, set hard in autumn and are discarded in winter. Early man collected these

cast-offs and used them for knapping flints and to carve into needles, spears and arrowheads. Antlers in early summer are firm, downy and warm; they pulse with warm blood like an aroused penis. In this 'velvet' stage, they've long been treasured in Chinese traditional medicine, ground into potions to enhance virility. Stags were symbols of sexual prowess as well as being a major source of food; they linked mankind to the tree of life.

Cows were living embodiments of the primal mother whose milk succoured both gods and humans. Milk can be churned, like the cosmic ocean, to make butter, pats of which are still thrown at statues of the gods in Hindu temples by disputing couples to cool their tempers and resolve discord. Everything cows produce is sacred in India; even their dung is dried and used as fuel for cooking and heating. A cow's life is a mystic thread that cannot be cut, and until recently these sacred animals wandered freely through all Indian city streets, leading charmed lives among the hooting cars.

People no longer believed they were in a living body, but they still felt tied to the world's beating heart by an umbilical cord. Mankind had been born but hadn't been cut off from the world's womb. This cord found expression in the endless, interlacing lines that became such a feature of our earliest designs in fabrics, carvings and metalwork. The intricate linear patterning in Shang Dynasty and Celtic metalwork, in Polynesian and Maori carvings and tattoos, and in the pottery and textiles of Amazonian and Peruvian tribes are among the most sophisticated images of abstracted grace that the world has ever seen. The people who made these artefacts believed that they were drawing an actual entity: the cord that linked all living beings.

Shimenawa ropes still festoon all ancient Shinto sites across Japan. They are woven of rice straws, and twisted like the churning

pole of Hinduism. Thin ones are used to bind a slender, ancient tree or surround a sacred water source; others over a metre thick lash massive boulders, jutting out from the earth's living core. These decorative cords define the perimeter of any ground where a new Shinto temple is to be built. They have to be in place, tied in an unbroken loop, before the ceremony of groundbreaking can begin. The earth must be assured that the delving spade will not sever its link to life. One of the most solemn duties of high priests and astrologers in early agrarian societies was to pronounce the most auspicious moment for the first seed to be sown. Every spring, kings, from the Inca of Peru to the emperor of China, wielded ceremonial spades to 'break the soil'. After that the order was sent out for everyone to begin planting. Severing the soil and sowing seeds were the most crucial actions of the year, for on these depended the future of the clan.

As we ploughed, sowed and harvested, we began to realise that we were different from all other creatures in a fundamental way. Squirrels could bury nuts in the ground to eat later. But they didn't plant them to grow into trees that would bear nuts for them to eat in the future. Only we could see that far ahead. But seeing further across a flat world meant that we must be higher up. It dawned on us that we had been born on top of the tree of life, and from this perspective, looking down, the branches below us seemed to be ranked in a measured arrangement. Our World Tree changed from being a wild contorted giant in the jungle into a stately presence, trimmed and orderly, growing in a garden.

This tree of life grew in the centre of paradise in China and in the Garden of Eden in the Bible, and its fruit rendered anyone who ate it immortal. Life itself was everlasting: this was the message of the World Tree. People died, as leaves fell in winter, but the tree itself went on living. The main duty of life was to pass life on, to keep the flame burning. This was one reason why twigs, particularly from

juniper trees, were used as wicks in tallow lamps and candles. Magically, and symbolically, the twigs when lit didn't burn. The Tree of Life was eternal. The menorah, the seven-branched candlestick of Judaism, symbolises this tree. Its seven flames represent the five visible planets and the moon, with the sun shining above them in the centre. The sun pours down life on earth and distributes its beneficence through the branches of the World Tree.

Every living thing had its allotted place on the tree standing in the centre of the universe. Nature ceased to be a churning convolution and became fixed in a rigid hierarchy. As the sun was king of the sky, so there had to be a king among humans and a king of the beasts. Lions used to range freely across Africa, Europe and Asia. They were the strongest of all animals, and had driven the other big cats into the shade, where they lurked, growling, in their striped, spotted or otherwise blemished coats. The lion's skin was unsullied, pure gold, like the sun. And the male lion had a mane, the only beast whose face was ringed with rays like the sun. So human kings began wearing golden crowns, manifestations of their earthly, heaven-ordained dominion.

The Great Sphinx at Giza, a recumbent lion with a man's head facing east, legitimised the Egyptian king's authority by associating him with the lion and the rising sun. A new face was probably added each time a pharaoh left his earthly throne to be reborn in the afterlife. The existing head of Pharaoh Amenemhat II was carved much more recently than the recumbent lion's body beneath. Kings had to prove their right to rule and their might by killing lions. Pharaoh Amenhotep III slayed a hundred at one go. Lion hunts became annual rituals in most kingdoms across Asia and survived well into the nineteenth century. The trapped lions had no chance of escape, let alone victory, against a king protected by cohorts of armed guards, but then it was held to be an honour for the lion to be killed by a man of such eminence.

Rank in human society reflected ranks in the animal king-dom. Kings, soldiers and farmers were like lions, eagles and bees. There were more bees than eagles, so there were more farmers than soldiers, but there was only ever one king. If you were at the bottom of the tree, you were among the many, and dressed drably, and if you were at the top, you were singled out and decked with gold. People did what they were born to do. Farmers gave birth to farmers, soldiers to soldiers and kings to kings, in exactly the same way that bees spawned bees, eagles eagles and lions lions. Feudalism wasn't a medieval invention, as has often been thought, but sprang from a much earlier system which endured because people believed it reflected how the world worked, a belief that enabled the majority to accept the consolidation of power by the already powerful.

Trees shaped our ideas of families. Millions of people still trace their ancestors by following a direct line of descent through first-born males. Noble ancestry tinted one's blood purple; if regal, it turned blue, the colour of heaven. The Old Testament documented the Judaic family tree: Adam begat Cain who begat Enoch who begat Irad who begat Mehujael who begat Methusael who begat Lamech who begat Tubalcain, the teacher of all those who forge iron and brass, and Jubal, the father of all those who play the harp and the organ. Jesus of Nazareth was a credible King of the Jews, for he was of the house of David, son of Jesse. His royal lineage was depicted in medieval stained-glass windows as a tree springing from Jesse's loins, on top of which sat Jesus, radiant in a golden halo. This was an image of Yggdrasil, stripped of its bestial and vegetative writhing, reincarnated in a neatly clipped form of Christian topiary.

The Ancient Egyptian practice of circumcision looks, at first sight, like an emasculation of male power, but was in fact a higher elevation. A tomb relief at Saqqara shows men cutting the foreskins of two youths in a public ceremony. Circumcision was an honour,

not a punishment – a sign that these young men had assumed a higher social role, and had unflinchingly suffered the pain of this initiation. They were purified by the operation, for it was written in the Egyptian Book of the Dead that the sun god Ra had circumcised himself as he rose from the earth. Circumcised men were more sun-like, shorn of their earthly shroud. Circumcision became widespread among the Ancient Egyptians and then the Jews, who lived among them. From Judaism the practice spread to Islam, where it became an essential sign of family membership of a faith.

We had been altering our appearance for millennia. People as disparate as the Inca in South America, the Huns in Germany and tribes in Tahiti clamped and battened selected babies' skulls to make them grow elongated, sometimes cone-like heads. This cruel distortion gave these children a distinctive, towering presence when they grew up, making them fit to rule over others. The gruesome, painful ancient Chinese practice of foot binding shortened girls' feet to four inches or less. Peasants had big feet and hands to work in the paddy fields, but ladies had little feet and grew their fingernails long to show they didn't have to work at all. Upper-class wives were the treasured possession of their husbands, born high up on the tree of life, and all the more secure because they couldn't run. None of these visible mutilations explain female circumcision, which prevented women from enjoying sex and, potentially, becoming promiscuous. Maintaining the purity of the male line was paramount. It was widely believed, right up until the eighteenth century, that sperm alone was responsible for creation. (The mammalian egg was only discovered in 1827.) Man was the generator, woman the receptor; he was the trunk of the family tree.

The emperor in the Chinese novel *The Three Kingdoms* is a tender, retiring wraith, prone to tears, standing in the midst of a maelstrom of warring factions, but his lineage made him untouch-

able. Kongming, the youthful Taoist hermit and brilliant military tactician, summed up the philosophy of inheritance: 'In man's short life between heaven and earth, loyalty and filial devotion are the foundation of personal integrity.' The most elevated ancestry was imperial; the next best, descent from a warrior or sage. It's still a haunting experience to visit the grave of Confucius and see the tombs of his direct descendants over the last two and a half thousand years, spreading for acres in all directions through a sepulchral wood, by far the largest single family graveyard in the world.

People looked for family resemblances, the arch of a nose, the set of a chin, and for similarities shared by whole groups, above all the colour of skin, hair and eyes. Those who looked alike must be alike. The mistaken but logical notion that humans are divided into families, nations and races had its origins deep in ancient history. The top of the tree, bathed in sunlight, was where the birds sang and the bottom, buried in shade, was where the pigs dug. People were ranked according to the colour of their skin. Light was the colour of the sun, moon and stars; it evoked hope and reason and everything that was good. Dark was the earth, burnt wood and excrement; it evoked fear, irrationality and all that was bad.

The Indian caste system grew from this observation. *Varna*, the ancient Sanskrit word meaning caste, also meant colour. At the top of society were the Brahmins, the priests, teachers, astrologers and healers, the men closest to heaven, who were invariably pale-skinned. Next down came the Kshatriyas, kings and warriors, politicians and police, who were slightly darker. Below them were the Vaishyas, the merchants and craftsmen, shopkeepers and servants, who were darker still. At the bottom came the Shudras, the untouchables who performed society's unclean tasks, such as shovelling excrement, removing corpses and keeping pigs; they were the darkest of all.

This classification became set at least three and a half thousand years ago. It stems from the era when fairer-skinned Aryan people began to invade India from the north-west, and conquered the indigenous, much darker-skinned Dravidian tribes who had edged their way to India along the coast from Africa thousands of years before. The northern Aryans might not have been able to assert their authority so strongly, nor to maintain it for so long, had not a hierarchy of skin colour appeared to be so logical. Advertisements seeking grooms and brides in local papers in India still display preferences for consorts with a 'wheaten' complexion. Racism wasn't a product of exploitation, though that was its consequence; it was a by-product of a world view which assumed that fairness was fair and that the fairest lived at the top of the tree.

The earliest religions were family faiths. Hinduism and Judaism were inherited beliefs which didn't countenance conversions until modern times. Followers felt tied to the faith of their fathers and through them to their founding godhead. This thread is still manifest in many ancient forms of worship. Zoroastrian priests tie and untie the Kusti, a cord made of seventy-two fine white wool threads, three times round their bodies as they pray facing a source of light and fire, the sun by day and the moon or a lamp by night. Ceremonial mazes, such as the outlines of celestial animals walked by the Nazca people in Peru and the circular maze on the floor of Chartres Cathedral, are expressions of this continuous line. A beaded cord tied in a ring, the rosary, ceaselessly slips through the fingers of Hindu, Buddhist, Muslim and Catholic priests as they say the prayers that tie them to their gods. The old English word *bede* means prayer. The problem was that more and more prayers were needed, for we had a growing apprehension that the thread that linked us to the sacred heart of existence wasn't just becoming attenuated and thin, but had already been broken.

Myths of a lost golden age, manifest most memorably in the Garden of Eden described in Genesis, were in part simply folk memories of those days when our numbers were few and we had more than enough to eat. Right up until the early twentieth century, the Tlingit people were fond of saying that their table was filled when the tide went out. The sea along their northern Pacific coastline was so fecund that a twice-daily feast of crustaceans and shellfish was exposed for them to pick and eat. But in more crowded regions, where we had to work harder to feed our increasing numbers, we began to realise not just that we'd lost our natural connection with the world, but that we were different from all other animals in a fundamental way. Only we were aware of our impending death. And with this awareness came a sense of dislocation, a feeling that we would never again be at one with nature, experience complete happiness or be content to walk naked among the world's creatures. Our Tree of Life had changed into a Tree of Knowledge.

There were two trees in the Garden of Eden. One was the Tree of Life, whose fruit rendered anyone who ate it immortal. The other was the Tree of Knowledge, whose fruit, once tasted, brought death. God forbade Adam and Eve to pick from the latter. A serpent was coiled round the trunk of this tree and it tempted Eve to eat its fruit, telling her she'd become like god if she did, because then she'd know both good and evil. Eve picked the fruit and shared it with her partner, Adam. Their eyes were opened. They discovered that they were naked, felt ashamed, and hid. God discovered them hiding, realised at once that they must have eaten the forbidden fruit and, in a fury, had them thrown out of Eden. He condemned Eve to labour in the pain of childbearing and Adam to labour in fields full of thorns and thistles, until they both returned to the dust from which he'd originally made them. Then he posted an angel with a flashing sword at the garden gate to prevent them stealing back to pick the fruit of the Tree of Life.

On one level this was a parable about growing up, learning about work and sex. But it was also a tale about our changing world picture. God condemned the serpent to crawl on its belly and eat dust for the rest of its life, to be hated and feared by all women and to be struck on the head by men. The serpent was demonised in this way because he represented an old world view that had to be eradicated. The universe no longer had a twisting, organic vortex at its centre, churned by a serpent's coils. Nor was the whole of creation threaded through with the cord of eternal life. Men were different from beasts because they knew right and wrong. They had souls that linked them to god, and were cut off from this world.

Other ancient myths record this change in our perceptions. The Athenian hero Theseus braved the dark labyrinth of caves to kill the Minotaur, the monstrous, bull-headed man who ate youths and maidens. He laid behind him the skein of thread that Princess Ariadne had given him so that he could find his way out again into the light. Midas, the legendary king of Phrygia, tied the ox cart of his father Gordias to his palace gate, proclaiming his humble inheritance and undying bondage to the soil with a knot that was too convoluted to untie. Elaborate designs showing the contorted, continuous thread of the Gordian knot decorated Roman pavements and early Christian illuminated manuscripts and continued to exercise the mind of Leonardo da Vinci in the fifteenth century. But this cord had long before been cut. Alexander the Great, passing by Midas' palace gate, took up the challenge to untie the knot, but soon lost patience and sliced through it with his sword. The umbilical cord, the thread that tied us to the Tree of Life, had finally been severed. Mankind had left the world's womb.

Chapter 4

Pyramid

When the Great Pyramid of Khufu at Giza was newly built, some 4,500 years ago, its four vast triangular sides were entirely covered with smooth white marble. The two smaller pyramids beside it, those of Khafre and Menkaure, were similarly dressed in slabs of polished red granite. Almost all of this casing stone was removed over a thousand years ago, mainly to build the first mosques in Cairo, leaving three gigantic ragged wrecks, their slopes corrugated with dark shadows. With their original facing they would have gleamed in the desert sun, more like colossal crystals than the work of human hands. Their contrasting colours may have had a symbolic meaning related to that of the red and white stripes painted on the walls of tanks in Hindu temples, and at the sacred sites of traditional Aborigines, which evoke the mystical fluids of menstrual blood, semen and milk. Our earliest world pictures were centred on sex and generation, but pyramids were founded on a larger truth which harnessed powers beyond our personal lives.

The appearance of the pristine Pyramid of Khufu would have changed dramatically as the day progressed. Like all pyramids, it is aligned to the four cardinal directions, and the significance of this orientation became evident each dawn. In the first dim light the whole structure was a shadowless pale grey. Then, long before sunrise, the tip of its eastern slope began to flare. This was a mysterious sight for ancient peoples, who had no idea where the sun was or even if it existed before it rose above the horizon. As the small arrow of light gradually lengthened and turned pink, a descending tide of warmth lit up the whole east flank, while the other sides remained in shade. Suddenly, the tip blazed gold. The sun had sent a signal of its coming birth. The brilliant triangle of light grew imperceptibly downwards until the whole eastern face was aflame. Trumpets surely sounded and priests chanted when the light touched the base of the pyramid, for at that moment the sun itself came into view, rising over the rim of the horizon and pouring its life-giving rays across the rolling sands.

As the sun climbed higher in the sky and light and heat filled the air, the Great Pyramid glowed ever more intensely white. By midday in midsummer, when the sun was directly overhead, the whole structure, with all its sides now free of shadows, had ceased to look like stone. It became a pyramid of light, a sunbeam made manifest, its base melting into the illusory band of mirage that hovered above the baking desert. The sunlight, reflected directly out from its sides, sent four blazing rays to the north, south, east and west, the beams of a star born in the centre of the earth. Viewed from an angle, without being blinded by its rays, the pyramid no longer looked like a mountain, but the sail of a celestial ship journeying across the waves of sand at the summit of the sun's diurnal life. This transformation had added resonance, for buried deep beside the pyramid was a colossal boat, built of cedarwood from Lebanon, whose nightly func-

tion was to carry the sun back to the east across the ocean under the world.

When the sun started to descend, the west flank of the pyramid shone rose pink, as the other sides receded into shade. Then, just before the sun set, as the glowing red disc stood on the rim of the horizon, its horizontal rays turned the western face into a massive triangle of copper red which pointed up to the first stars, shining in the darkening vault. Priests would have officiated at this nightly spectacle, chanting prayers into the cooling desert air, as a great grey shadow rose up the side like a swelling tide. Though the sun itself had long since disappeared, the pyramid's western point still glowed, a last signal from the dying god. Then the tip of flame was quenched.

At that very moment the pyramid appeared strangely whole again, muted but shadowless, as it had been at dawn. But as the vast dome above it became dark, the whole edifice mysteriously brightened. It seemed a pallid spectre of what it had been by day, floating eerily on a sea of sand that was now velvet blackness, much darker than the star-filled sky. When the moon rose another spectacle began, white tip appearing to white tip disappearing, which culminated when the moon was at its height and the entire pyramid shone silver, pure and still, a ghostly refection of its presence in the day. The pyramid had asserted a wondrous truth: it had not been destroyed by death.

Ten thousand years ago, after the ice had melted and the sea had risen and flooded the marshy estuaries where we had first lived, we began to cultivate the upper reaches of the fertile valleys of the world – the Nile, the Tigris and Euphrates, the Indus and the Yellow River and, some time later, the fertile plains around the Gulf of Mexico and along the Pacific coast of South America. We enjoyed living in larger groups; there was safety in numbers, and more hands made

for lighter work. We began to plot and to trade, and invented arithmetic and writing to help us keep accounts and records of our deals. We took over attractive neighbouring territories by marriage or exchange, trickery or force. Civilisation flowered, first in Mesopotamia and Egypt, then in western India and northern China, and later in Mesoamerica and on the western slopes of the Andes. Though very few of these societies knew of the existence of any of the others, in all of these places – with the apparent exception of India – our new urban centres began to sprout colossal constructions with a square base and four sloping triangular sides.

Early human history is generally described in terms of technological advance, a chronological progression from Stone Age to Bronze Age to Iron Age marked by a continual series of discoveries, inventions and breakthroughs. The Norwegian anthropologist Thor Heyerdahl caught the world's imagination in 1947, when he succeeded in sailing the balsawood raft *Kon-Tiki* across the Pacific, and again in 1970 when he crossed the Atlantic on the papyrus raft *Ra II*. These voyages proved that it was technically possible that mariners from Asia and Africa could have spawned the civilisations of Peru and Mexico. Though DNA testing has since shown that no such migrations took place, it has been argued that there must have been some connection between these peoples to explain the correspondences in their cultures. In fact, pyramid building was not inspired by one culture following another, but developed quite independently by societies which shared the same world view. People built pyramids because they thought they were living in the centre of the world, and weren't aware that any other culture existed.

Pyramids were immaculate and self-contained, symmetrical and eternal. They weren't like bodies, mountains or trees; they didn't emerge from the earth, nor did they grow or die. They were cut off from life, standing on the flat horizon which we had discov-

ered within nature and now believed to be the basis of everything. Our new view of the world was geometric rather than organic. Wherever they were, pyramids had a remarkably similar form, with a square base and four sides oriented to the cardinal directions. Some were stepped, others straight-sided, but all were variants of this singular shape.

The earliest, made of stacks of mud bricks, were invariably immense. A huge earth pyramid overshadowed the huddled dwellings in the Mesopotamian city of Uruk and another dominated the earliest large settlement in the Americas, the Olmec capital La Venta. The first stone pyramid was erected at Saqqara in Egypt around 2,600 BCE, and the Egyptians eventually built over a hundred of these colossal monuments. In the sacred city of Teotihuacan, the pre-Aztec people of Mesoamerica erected a vast assembly of pyramids over a period of a thousand years. The practice of pyramid building emerged independently at various periods in different cultures around the world, and then disappeared from them, as suddenly and mysteriously as it had begun.

Subsequent generations have invented all sorts of hidden purposes for these strange constructions – astrological instruments, secret symbols of mystic cults, messages to or from aliens in outer space. Practically minded Christians in western Europe decided that they must be the grain stores referred to in the Old Testament, built by Pharaoh after Joseph interpreted his dreams as prefiguring seven years of plenty followed by seven of famine, so medieval illuminators depicted them with doors and windows which jut absurdly out of their sloping sides. Pyramids have remained mysterious largely because they don't have any obvious function. They are most commonly thought of as tombs, but even that use doesn't explain their unique, distinctive form.

In Egypt, China and Mesoamerica they mark the site of royal burials, but the sarcophagus of the king was always under, rather

than inside them. Their burial chambers might equally well have been capped with a dome or a cone, or indeed nothing at all, as became the practice in Egypt during the Middle Kingdom, when graves were hidden to prevent looting by robbers. Many of the pyramids in other parts of the world have no obvious relationship to tombs. Some of those in Iraq and Mexico have small temples balanced on their summits, but these have the rather apologetic appearance of afterthoughts, which hardly justify the immense mass of masonry underneath. The majority of those at Teotihuacan seem to have stood alone, solid constructions with nothing in, on or under them. The world's many pyramids are by far the largest non-practical structures that human beings have ever created, and we must have had very good reasons for undertaking the gargantuan effort required to build each one of them.

The point of a pyramid is its top. Though the finished construction appears to rise from its base, it has to be conceived and designed from the peak downward. Its planning and construction required a vast amount of forethought, the mental ability which, to our ancestors, separated us from the animals and made us godlike. The masons of the Great Pyramid at Giza were so fully in control of what they were doing that they could prepare an absolutely flat, horizontal surface 230.4 metres square, then lay on it two and a half million colossal blocks of limestone, each weighing up to sixteen tons, and so immaculately placed that the gaps between them rarely measure more than half a millimetre. The topmost blocks meet 146.5 metres above the exact centre of the base. The key to this precision was the knowledge of stone-cutting, a new adventure for humankind whose beginnings signal the opening of another chapter in our quest to comprehend the world.

Though we scratched images on cave walls, carved tools, figurines and amulets out of loose stones, and knapped flints we found as nodules embedded in soft chalk, there's no evidence to suggest

that we cut into bedrock until about 10,000 years ago (though earlier rock-cutting might well have been hidden by rising seas after the last Ice Age). We didn't alter our natural surroundings in any substantial or permanent way to suit ourselves, not even by flattening a ledge under a rock shelter to make it more comfortable to sit or lie down on. Undoubtedly we made comfortable beds of straw and fur, but digging into what we still call the living rock appears to have been taboo for most of what we refer to, rather confusingly, as the Stone Age. The 1960s cartoon series *The Flintstones* gave an intentionally ludicrous (though still tenacious) picture of the everyday life of 'cave-men'; in fact, apart from some tools and weapons, very little in the man-made environment at that time was actually fashioned from stone. The expendable tips of the earth's bones could be used, like nails or claws, to cut, scratch and kill, but the skeleton itself remained sacrosanct.

The evidence of our first attempts to overcome this taboo (and indeed that against baking clay, which makes a similarly late appearance in mankind's history) must have been lost with the rise in sea levels around 12,000 years ago. There are fascinating isolated examples of rock cutting at Göbekli Tepe in eastern Anatolia, Ġgantija on the island of Gozo, and Skara Brae on Orkney, but the early history of mankind can't be viewed as a single chronological development; it was a series of overlapping cycles. The first two sites were places for the dead, not the living, and Skara Brae makes much more sense as a community sauna – a place for telling stories about spirit ancestors through the long winters – than it does as a village, providing everyday accommodation. In these early instances stone appears to have been cut for eternal uses, not the fleeting present.

None of these comparatively modest breakthroughs, however, was a direct precursor of the Egyptian funerary temple of King Djoser, which was built around 2720 BCE at Saqqara. This immense

complex was made entirely from exquisitely chiselled stone masonry. The three Pyramids of Giza are visible on the horizon looking north from Saqqara, a mere twelve miles away across the desert. Only a hundred and fifty years separates mankind's first elaborate stone building from his greatest. The Great Pyramid remained the highest man-made structure in the world for nearly five thousand years, until the erection of the Eiffel Tower. A revolution had suddenly taken place in human thinking.

The funeral pile of Djoser's father King Khasekhemui had been made of mud bricks. But his son's extraordinary monument wasn't the product of a technological breakthrough; the masons built it using the tools they'd had before, made of stone or copper which were more appropriate for working softer materials such as wood. Apparently overnight, the Egyptians had attained stupendous skill in handling stone, combining supreme artistic expression with precision engineering. However, although they had overcome ancient taboos about digging into the earth's bones, stone remained for them a sacred substance, reserved for the eternal palaces of their deceased god-kings.

The division between life and death is still clearly marked in Egypt. You can stand with one foot on cultivated grassland periodically inundated by the floodwaters of the Nile, and with the other feel through your sandal's thin sole the baking heat of the sand in which nothing grows. The Ancient Egyptians lived a life of fecundity and ease along the banks of the Nile, inhabiting a world of shadowy reflections and annual floods, where everything changed in the cycle of life. On either side of them, to the east and west, where the sun was born and died, stretched the lifeless deserts of eternity.

The world's first elaborate masonry structure is a celebration of transience made eternal. The palace the king had lived in down in the fertile valley, shaded by palm trees and surrounded by gar-

dens, was recreated for all time in exquisite detail, as if the sun had etched its shadows into the hot rock. A rolled-up reed mat, carved in stone, hangs eternally above a stone doorway, ready to be dropped down if the night should turn chilly. In the garden, shade is provided by stone trellises, their pillars in the form of bundles of tall rushes bound together with ropes, each stone stem and knot perfectly fashioned. A stone door, swivelled on its hinges, stands forever ajar. Even in eternity, a king couldn't be expected to open a door for himself. And next to the palace is a huge, step-sided pyramid, the first ever built of stone.

The Egyptian breakthrough in stone working has been attributed to the genius of Imhotep, the master builder of Saqqara and the first architect whose name has come down to us from history. He has been claimed as a sort of precursor of Leonardo da Vinci – a brilliant polymath, famous in his time for advancing medicine and developing writing as well as for his innovations in building techniques. Still visible today at Saqqara is a remarkable survival: a thin red line made by a cord snapped against a wall to establish a horizontal. An incomplete inscription nearby suggests that Imhotep inspected this line every day; without horizontals nothing could be built in stone, certainly not a pyramid of any size. But the horizontal had a much greater meaning for the Ancient Egyptians than for us today. It was profoundly symbolic as well as practical. A horizontal was a horizon, in the broadest sense.

Although our ancestors' world was flat, the ground they walked on naturally undulated and sloped this way and that. Only water established a true horizontal plane, and it stayed level whichever way you tilted a cup which held it. The most perfect expression of extensive flatness was the surface of the sea. So we came to believe that sea level must extend as a level plane through the middle of the world; this level carried all weight, and all verticals

could be judged against it. A central horizon running though the earth was the mysterious basis of existence. But no matter how far anyone dug down, or ventured into underground caves, no one had yet struck the level on which the world was based. The horizon that ran through the earth was insubstantial, like the waters of the sea which no one could walk on. But it was this horizon which divided the world in half, and drew the line above which the sun lived and below which it died.

There were different ways for the stone workers at Saqqara to determine the invisible horizontal. They could simply pour water on to a surface to establish its deviation from flatness. They might also have used a version of the spirit level, a bubble of air in an oil-filled glass tube. (They certainly had the technology to make this, though no such instrument survives.) But there was one alternative method: they could bring gravity into play. Gravity was the other great invisible direction in life, a force which everyone could feel but no one could see – the weight of a stone held in your hand, the heaviness of your limbs after strenuous work. The Egyptians invented the plumb line, a length of cord with a weight at one end, to locate this force and determine verticality, which could then be divided to establish the horizontal. Geometry held the key to the secret forces of the universe.

What is more significant is that our feeling for geometry appears to have sprung from an inner spiritual awareness. Our ancestors became fascinated by their ability to judge the correctness of verticals, horizontals, angles and arcs by eye alone, and masons developed this skill with pride. (The great buildings of the past, from the pyramids to Gothic cathedrals, were all built primarily by eye, and then checked, if necessary, with rulers and compasses.) The implication was that we had a direct line of communication with the forces of the universe. This knowledge distinguished us from other

animals, and must therefore be god-given. Assessing verticality was related to our ability to calculate what would happen in the future, another aptitude we had which raised us above the level of beasts. Planning a pyramid was in itself an act of spiritual praise. Imhotep – the noble, perhaps half-divine, master-builder – inspected the horizontals every day, and judged them with his inner eye. He needed no instruments to help him; his sense of rectitude, balance and righteousness was inspired.

Horizontals and verticals form the core of all pyramids, but they don't determine its planar, angular shape: a flat base and perpendicular central axis could equally support a cone, or a dome. The cone is a very much simpler solid to conceive, being the shape most naturally formed by heaping stones, earth or leaves, as well as that of a tent made with leaning sticks. Cones have symbolic meaning, evoking nipples, beaks and buds – life's beginnings. Domes can also be easily created in nature, by bending branches to form a framework for a hemispherical shelter. They reflect the sky, heads and breasts, the ripeness of life. These curving shapes are encompassing and embracing, providing cover and protection to gather, eat and rest.

Technological historians have assumed that pyramids were made with flat, planar sides because no one had yet worked out how to construct arches and domes. But anyone with the technical ability that went into making a stone pyramid could surely have built anything. The Inuit constructed igloos out of subtly chamfered, straight-sided blocks of packed snow without knowing about the arches of the Romans. Pyramids were about straight lines, not curves; they were solids rather than containers. What their architects were attempting to capture and harness was the secret, eternal geometry, the mysterious fixity that held the universe together.

Mystic forces ran through the world: the pull of up and down intersected by the horizon of the sea, the east–west path of the sun

crossed by the movement from north to south. Everyone living in the northern hemisphere could identify the North Star, shining brightly in splendid isolation. We knew the air grew colder towards the north and warmer as you went south. The daily path of the sun from east to west took it from birth to death; travelling from north to south had the opposite effect – it was a journey from the chill of death to the heat of life. But there was no South Star in the heavens, because no one could attain eternal life on earth. Once people had reached the high point of their lives, they turned and travelled north again towards their death, just as the sun began to sink back down to earth after reaching its zenith at midday.

The Nile, the river that flows through the centre of Egypt, runs from south to north. The annual flood came from the south, reviving the whole valley. The flow north was a journey towards death and hoped-for rebirth, for the Ancient Egyptians believed that the Nile led to the river of heaven, the Milky Way, where stars were born. Their pyramids flank this sacred river, as those at Teotihuacan are ranged along the north–south avenue which divides the great Mesoamerican city. This axis was fundamental to the culture of many early civilisations. Its crucial part in the rituals of the ancient Chinese led to the invention, almost two thousand years ago, of the compass, which enabled them to determine the direction of the North Pole with precision. Varanasi, one of the oldest continually inhabited cities in the world, is sited at the place where the south-flowing River Ganges turns briefly north. Like the Ancient Egyptians, Hindus believed that their holy river had its source in the Milky Way, and still today many go to Varanasi to die, so that their souls will be carried straight back to heaven and enjoy a higher, happier reincarnation.

The Great Pyramid at Giza was referred to in contemporary inscriptions as the 'Horizon of Khufu'. This was the line between life and death, from which people were born, to which they would

return, and from where they hoped to be born again. The reason for burying a king beneath a pyramid was that this massive structure focused the hidden forces of the universe, which would help him to rise again after death. The king was laid out at the point where the six directions intersected. These were the axes which gave the pyramid its shape, forming an eternal core at the heart of all flux. For the terrifying reality of existence was that everything in the world was subject to change and decay; even the sun died daily in a pool of blood.

The Egyptians worshipped many living creatures, from bulls to snakes to cats. Bizarrely, they divined a relationship between the sun and a ball of dung, brought about through the intervention of a beetle. The female scarab rolls a piece of cowpat into a little ball, lays its eggs in it, and then pushes it down a hole. When the grubs hatch, they feed off the dung, and eventually crawl out of the hole as new scarab beetles. For the Ancient Egyptians, this remarkable process mimicked the way that the sun disappears beneath the horizon and is then born again. Royal pendants retell this tale of resurrection, not in earthy beetle browns but in glorious gold, lapis lazuli and amethyst, showing the stars up in the sky, the waters of the world below, and the scarab standing in the solar boat ready to push the sun up at dawn. The scene is flanked on either side by figures of baboons, because these monkeys greeted the sunrise with shrieks of joy. In the Ancient Egyptian mind, poetic beauty embraced all creation from the humblest insect to the highest god in heaven.

Pyramids were poetic, the eternal heart of all mystery. Their solid mass was intrinsic to their meaning, for weight was a wonder in itself, invisible but urgently real. The bigger and heavier they could make them, the more effectively they would focus the forces of the world on the invisible horizon that sustained all life. The remains of a hundred and eighteen have so far been identified in

Egypt, built over a period of a thousand years with pride, ambition, skill and patience. The massive numbers of people involved in their construction were not slaves, chained in gangs and whipped by cruel pharaohs, as the popular image derived from Victorian panoramas and Hollywood epics would have it. Labour was provided in lieu of paying tax, and excavations of the huge kitchens and ample living quarters at Giza show that the workers were well fed and treated with respect.

Contemporary inscriptions very rarely refer to the pyramids, except occasionally as 'horizons', and their meaning is never explained. This doesn't mean that it was a secret, but rather the reverse: it was too obvious to mention. They didn't need a name – they weren't things, but the essential, eternal nature of everything. They were solid because the world was solid; that was as obvious as the fact that it was flat. It was the Ancient Greeks who coined the word *puramis*, two thousand years after the Egyptians first built them in stone. Plato's definition of this was 'the solid which is the original element and seed of fire.' Pyramids were images of essences, seeds of the sun, prime foci of the six directions, the source of all power. They weren't just one of the wonders of the world: they were the wonder of the world.

Chapter 5

Altar

Our horizons were growing wider as we travelled further and traded with people from distant lands, but wherever we went the stars at night remained the same, circling round the pole, never shifting their relative positions, and the sun and the five planets journeyed across the sky, always along their set paths. Among these heavenly bodies only the moon changed shape, was born, swelled and died and then disappeared for two nights. We began to conceive of another horizon above sea level on which the moon floated, separating eternity above from the mortal world beneath. As bubbles rose through water to return to their natural element, so flames and sparks rose through the air to their luminous home among the stars where the atmosphere was clear and pure, not like the corrupted and corrupting vapours we breathed down here on earth. Heaven had entered our perception of the universe.

We had become used to thinking of our flat world in terms of layers, manifest in the spreading branches of the World Tree and

the horizon of the sea. Nature's tiers had shown us how society should be organised. But the idea gradually began to take shape that one upper level reigned supreme. This division explained a bewildering anomaly: the stars went round at night, so heaven above had to be circular, but the flat earth below had four directions and therefore had to be square. That raised the question of how the two could be connected. We came to the reassuring conclusion that they weren't related and didn't need to be; the afterlife we would enjoy in heaven was totally separate from the life we lived and suffered, briefly, in the world below. An altar began to take shape in our thoughts, a spiritual level separating eternity from mortality.

Our universe became split horizontally and the two halves obeyed different laws. Pure circles were celestial beings – the unchanging sun, the rotating stars and the moon when she rose to fullness once a month. But complete circles were an exquisite rarity when we looked about us. Arcs and hemispheres hinted at their existence, in breasts and smiles and in rainbows that appeared in stormy skies. This was only to be expected; people living in a lowly, impure state couldn't see heaven as a whole. The exceptions to this rule were the pure circles to be seen in eyes. But these were easily explained: eyes were gifts from above, for without sight no one could see the stars. All animals had round eyes, but only we had circles surrounded by pure white. Round centres could be found in many flowers, but then they too lifted their heads to praise the sun. The only other pure circles on earth also came from above: raindrops made perfect rings in water, each one rippling wider and wider until the rain's sweet beneficence was spread across the earth.

Sight was the supreme sense, because we could obviously see much further than we could smell, taste and touch and even further than we could hear. And sight travelled faster than hearing, for you could see an avalanche crashing down a distant mountainside before

you heard its roar. We knew that different stones and woods made different notes when struck, and reeds sang when blown. Everything had its own sound. But no matter how hard we gazed up at the stars, they remained out of our range of hearing, though we were sure they must make the most glorious music of all.

Sight was our highest sense, for only the tips of our ears came up to the level of our eyes. Beneath these came the lesser senses of smell, taste and, lowest of all, touch. Our hands could reach down to our genitals – organs we had in common with animals, positioned near to or sharing our excretory orifices. Our heads, where our eyes shone like stars, were domed like the sky, but the rest of our bodies became increasingly bestial as we looked down at them. And at their lowest point, our feet stood on the ground from which our bodies had been born, and to which they would return after we died, as heavy, cold and horizontal as the earth itself. The spirit which lifted us up and inspired our bodies with life was the light that shone out of our eyes. Sight was the beacon of our being, the sparkle in our eyes that would be extinguished when we died as our spirit flew back up to the twinkling stars.

Among the earliest signs cut into stone are the so-called cup and ring marks, which have been found on exposed bedrock on the brows of hills from Mexico to India, with a concentration in northern Europe. These little gouged-out hemispheres ringed with concentric circles look exactly like ripples formed by raindrops, but in stone, not water. They were star-drops from heaven made permanent in the changing world beneath. Gullies sometimes run down from their centres like umbilical cords from the navels of newborn infants. Water, blood or beer poured into these cups and channels would have reflected the stars as they moved round the night sky. These star-mirrors brought celestial influences down to earth when sickness or danger threatened or when death called a spirit home.

The most mysterious lines traced on the surface of the earth were made by the Nazca people of Peru. On a high, arid desert plain above the valleys where they lived, they created immensely long paths of light by clearing away dark rubble and topsoil to reveal the pale clay beneath. Most of these pathways run straight from horizon to horizon but some twist, turn and double back across the flat plain, creating continuous lines as in a hedgeless maze. These patterns don't make any sense when looked at across the ground, but when viewed from above they can be seen to trace, with delicate precision, immense outlines of creratures such as the hummingbird, monkey and spider that lived in the mountainous rainforests far to the east. The Nazca appealed to the spirits of these animals in the stars by walking their profiles and chanting hymns. They prayed that these gods would send rain to the mountains, which would swell the rivers and feed the long channels they had dug to irrigate their dry valleys below. These ceremonies were performed high above their homes, halfway to heaven, on a sacred plateau open to the sky.

It wasn't only the world that was split horizontally; so, too, were our thoughts. An altar existed within our heads separating the eternal from all that was ephemeral. The Nazca lines were drawn with the mind's eye. They were the product of our remarkable, god-like ability to see ourselves from the outside, as if we were looking down on the world from a great height. Our ancestors carefully cultivated this mental agility which enabled them to see things from a heavenly perspective. In traditional Aborigine paintings almost all the landscape features, the rivers, hills and waterholes, are shown diagrammatically, as if viewed from above. Even humans beings are reduced to u-bend shapes sitting round a fire, crouching figures with protruding knees, as if seen by a bird flying overhead.

The early so-called primitive artefacts of the world weren't failed attempts to render likeness. The backward-bending, flattened,

lozenge shapes of Cycladic figures, the massive stargazing heads of Easter Island and even the full-face and profile juxtapositions in Egyptian art were intentional and sophisticated abstractions, mental imaginings, not earthly renditions. It was taboo to depict spiritual and heavenly beings in a representational way, because that would suggest they were standing on the earth, which they would never do. Celestial beings could only be pictured in our mind's eye.

Abstract, heavenly thought governed the construction of the world's oldest communal altar, Göbekli Tepe in Turkey, which was in use 12,000 years ago. Its strange T-shaped pillars are flattened images of men, with simplified heads jutting out in front and behind and arms pressed close to their sides. Their fingers reach round to just where the man's penis would be, transforming the whole pillar into a phallic erection. It requires an imaginative leap to see the pillars in this way, but that was just the sort of elevated mind games early people loved to play. Many of these pillars are decorated with low reliefs of foxes, lions, deer, wild boar and cranes. Some of these animals look as if they are leaping, but their posture and the droop of their paws suggests that they are hanging rather than attacking, and they could represent pelts slung over shoulders, attributes of high-ranking men.

The T-pillars are arranged in a circle, their sides radiating out from the centre where two taller pillars stand side by side, oriented due east and west. There are nineteen of these circles on the site, only four of which have so far been unearthed. The excavations, which began in 1995, have found no evidence that these strange T-shaped pillars supported roofs, but they must have been functional as well as symbolic. The likelihood is that they supported a circular raised walkway on the outside and a rectangular stand in the centre, made of wooden planks which have long since disappeared. The circles were probably most in use for funerals. The mourners walked

or moved on their knees round the outer rim, emulating the rotating stars, chanting prayers to heaven to welcome the soul of the departed whose body lay on the central stand. All Islamic sects in Turkey still place the bodies of their dead on similar, simple raised altars in the open air, oriented east and west, which indicates a common, much older ancestry for this practice. Both the body and the mind had to be raised if a spirit was to be lifted to heaven.

An altar existed in our minds, the horizon between wakefulness and sleep. Sleep gave us the sensation of sinking, as if beneath the surface of the sea, but, remarkably, it also gave us a taste of life after death. Dreams of flying must have been as common in the past as they are today, but much more startling in their implications. People used to take great care not to wake someone up too suddenly, fearful that their errant spirit wouldn't have time to return to their body and would be condemned forever to wander in the upper realm. Dreams had to have meaning, and their interpreters were highly regarded in all early societies. The Egyptian Pharaoh raised the Hebrew Joseph to rule over his kingdom because he alone correctly interpreted his dream foretelling seven years of plenty followed by seven of famine. In India the Mughal emperor Akbar built a beautiful little canopy next to his throne in his palace at Fatehpur Sikri especially to house his dream-reader and astrologer. Dreams and stars inhabited the same spiritual plane.

There was another way up to the heavenly realm. Just as fire was hidden in twigs, narcotics were secreted in flowers, fruit and leaves. Our ancestors believed they had discovered the hidden, treasured food of heaven, the nectar of the gods, for such mind-enhancing substances could only have come from the upper realm. Traces of beer have been found in tombs from Egypt to Denmark, sealed in amphorae or poured into buckets made of bark, ready to be drunk in the afterlife. The graves at Ur, in Mesopotamia, contained long

straws, made of tubes of gold and lapis lazuli (the colours of the sun and sky) to enable their resurrected kings and queens to enjoy the clear, intoxicating ale suspended between the frothy head and the sunken lees.

In tribal cultures shamans and witch-doctors administered opium to the dying, partly to ease their suffering but more importantly to prepare the spirit for its approaching elevation. Many early religious practices were centred on drug use. Soma (or haoma), a mildly stimulating effusion extracted from the ephedra shrub, was the crucial ingredient in the sacred drink used in both Zoroastrian and Hindu worship. In the Americas (a continent exceptionally rich in intoxicants) cocaine, tobacco and magic mushrooms were central to Mayan, Aztec, Inca and North American Indian rituals, especially those involving human sacrifices.

Wine was so good it had to have been made by a god: he was called Bacchus in Greece, Dionysus in Rome. Turning water into wine became one of the most popular miracles performed by charismatic leaders in ancient Mediterranean cultures, including Jesus of Nazareth. The first director of the ancient Museum of Alexandria, Ctesibius, was reputed to have invented an automaton that could perform the trick, operated by putting a coin in a slot. But too much wine affected your sense of balance and ability to walk along a straight line, indicating a fall from grace and loss of sanctity and rectitude. Buddhism and Islam eventually outlawed wine, but Christianity absorbed it into their communion sacrament. The ceremony of drinking wine as the blood of the crucified saviour was a surprising symbolic revival of ancient sacrificial rituals palliated by drugs.

Music and dance were ways of lifting people's spirits without deleterious side effects, though in some strict religious regimes, particularly Christian and Muslim, these activities were eventually outlawed for they were thought to be, like alcohol, more stimulating

for the body than the soul. Dance had been a natural form of spiritual expression when people felt at one with the body of the earth and linked to all other living creatures. Shaman dances, with masks, often mimicked the movements of ancestral animals: a lion's leap, a frog's jump, the crane's bizarre mating gambol. These dances frequently built up to frenzied climaxes which stimulated sensations of flying. The followers of the heterodox Muslim poet and mystic, Celaleddin Rumi, achieved a beatific state by whirling. In the chief hall of their faith in Konya, on a flat, square floor (representing the earth) beneath an exquisitely patterned dome (representing heaven), the dervishes, shrouded in white (symbolising their approaching death), whirled for hours, their feet barely touching the sullied ground as their spirits soared to the circling stars.

Our souls were lifted far above our mortal frames by sounds. Instruments were popular grave goods, buried with Chinese emperors and the kings of Mesopotamia, and sacrificed in bogs in Denmark. We know the sounds they made but virtually nothing of the music they played. Notes in themselves were mysterious, contained within wood and stone, reeds and strings, metals and stretched skins. Like fire, music was hidden on earth but linked us to heaven. Notes were the voices of buried spirits. The stone gongs found in Chinese tombs rang with the cries of their departed ancestors. The earliest scale in China had five notes, the sounds of the five planets. There was a widespread belief that the stars sang a haunting and terrifying song when a dying soul rose to join them. If you heard this eternal melody, your hour had come. It wasn't given to lowly mortals to hear the music of the spheres.

People's lives were split between the circulating stars and the square earth below. These two basic geometric shapes haunted our thoughts, and up to a point still do, for a bull's eye, the centre of a circle, and a cross, the middle of a square, remain in target practice.

The most perfect expression of this fundamental geometry in ancient times can still be seen in the Pantheon in Rome, which was substantially remodelled during the emperor Hadrian's reign in about 126 CE. The building is a sphere within a cube, originally standing on a raised, flat dais with an entrance facing due north. Its dome, an extraordinarily ingenious, graduated honeycomb-like structure, is still the largest span of unreinforced concrete in the world. At its apex was an oculus, a circular opening to the sky which cast a disc of sunlight on the walls and floor beneath, which moved throughout the day, acting as a sundial. No contemporary records exist of what this extraordinary building was for. The word 'pantheon' appears to have been a sort of nickname, meaning a home for all the gods, but the building was apparently not used as a temple. The probability is that, like the pyramids, it did not have a name because it was an image of everything, a flower of common sense.

Circles and squares were the essential geometric building blocks of Chinese culture, a civilisation that had many similarities to Imperial Rome. These two shapes are manifest in the mysterious Bi discs and Cong rods that are commonly found in ancient Chinese graves. They are always exquisitely carved in jade, the immensely hard stone that the Chinese believed imbued anyone it touched with eternal life. Bi discs are similar in size and shape to modern CDs. One side is plain but the other is covered with equally spaced little raised hemispheres, a simplified, circulating star pattern.

Congs are hollow circular rods sliced through with square slabs at intervals, looking somewhat like modern CD racks. The four corners of these slabs are usually decorated with two eyes and a mouth. People in China at that time thought, like the Arabs who built the Ka'ba in Mecca much later, that the corners of the flat, square world faced the cardinal directions, not its sides. These corners formed narrow angles, like pursed lips, funnels from which the

four winds blew. Cong and Bi discs were summations of the organising principles of the universe, placed in a grave to ensure longevity. One of the skills that the mandarins of China had to master was to draw a circle and a square simultaneously with each hand, demonstrating not only their mental control, but also their capacity to grasp the meaning of existence on earth and in heaven. A disc punctured with a square hole was, for millennia, the main coinage of China.

When the Chinese emperor performed his religious duties, he was carried everywhere in a chair, as the Egyptian Pharaohs had been and the Christian pontiff still is. Once a year, however, at the time of the winter solstice, the emperor walked on his own feet – not on the ground but across the Circular Altar in Beijing. This act of great humility showed his sympathy for the sun, which then barely had the strength to lift itself above the horizon. The current Circular Altar was built in 1530 CE but it reflects the shape of a much earlier original. It is an austere three-tiered stack of circular terraces, open to the sky, the topmost level of which is inlaid with blue stones. Surrounding it is a low-walled, square enclosure representing the earth, with four gateways flanked by stone cloud-pillars, facing the four directions.

Heaven was a circle; it revolved around the Pole Star which was, significantly, isolated among the stars. But the square earth didn't appear to have any discernible, fixed centre. Other nations' tales of mountains and trees, lakes and caves standing in the middle of their world diminished in credibility as we travelled more widely. And kings, who many thought stood in the heart of their kingdom, cancelled each other out, for no square can have more than one centre. The earth was flat and had directions: that much was certain. But then it occurred to us that that was enough. A centre was right for eternity in heaven but had no place on the transient earth. This

new understanding fitted our experience of time. Life on earth was a journey, following the sun's path from east to west, before we rose to enjoy eternity among the circling stars. All pilgrimages followed this pattern; Hindus, Christians and Muslims travelled as directly as they could to Mount Kailash, Jerusalem and Mecca, but when they arrived there they walked round the central, pivotal shrine. These were not centres on earth, but circular altars where the pilgrims could praise heaven.

The Great Pyramid at Giza was a summation of the forces that held the universe together, and yet it wasn't perfect. Its peak didn't end in an immaculate point but with a ten-metre square platform, an elevated altar invisible from the ground, the purpose of which has never been explained. Nobody could have climbed up to it, still less got to it from the inside. Perhaps the monument had originally been capped with angled plates of gold which were stolen when the pyramid was stripped of its dressing stone. Or it could have been left purposefully unfinished because its top was believed to pierce the sacred invisibility of a higher realm, which could only be represented by emptiness, a flat plane. It's possible that the people who built the pyramid had a premonition of a different world view.

The first sight of Queen Hatshepsut's funerary temple in Egypt still takes one's breath away. Something new had appeared in the history of mankind, as if a great bird had opened wide its wings. Our perception of the world had shifted from being centred to being layered. We'd ceased to build massive pyramids, and started instead to erect raised altars open to the sky, sacred avenues and walkways linked by sloping ramps and stairs.

Queen Hatshepsut ruled Egypt for twenty-one years. Since there wasn't a male successor within her dynasty, she had to reign, for bloodline took precedence over sex, but to do so she had to turn

herself into a man, as Queen Elizabeth of England and Queen Christina of Sweden effectively did much later. Statues of Hatshepsut show her breastless and wearing the standard royal false beard. Her funerary temple is at the foot of a high cliff that runs directly north to south. Three tiers of terraces lie close to the cliff foot. They are traversed by a straight ramp that runs east to west and disappears inside the cliff where it leads down to Hatshepsut's tomb. Obelisks once stood on the terraces, where the ramp crossed them, but these have long since fallen. These needles, later a famous feature of Egyptian architecture, were an invention of Hatshepsut's age: immensely tall, thin, square-sectioned granite pillars with pyramidal pointed ends. They were cut complete from the quarry – in itself a remarkable feat of carving and transportation. These needles were nothing less than pyramids pared down to their essence, pinpoints indicating gravitational direction. Like modern engineers, Hatshepsut's architect-priests had cut away the mass, and left only the line of force, a star-fall at the key crossing points of her journey from birth to death. Everything in Hatshepsut's temple is straight-edged; even the pillars supporting the terraces are square sectioned. The building re-enacts a journey across life, not the circular motion of heaven. The ramp was a processional way and its terraces were originally planted as a paradise, hanging gardens a thousand years before Babylon. Thirty-one frankincense trees were imported, fully grown, from the east, the first recorded instance of arboreal transplanting.

Our thoughts became fixated on heaven. We started to erect vast ceremonial altars open to the sky. These raised platforms aren't usually regarded as wonders of the ancient world, still less as works of art, because they were in the main surfaces, not monuments. There isn't even a collective name for them, but Persepolis, the Temple of Herod and the Forbidden City were massive, communal feats of engineering. Their impressiveness lies in their elevation and

breadth; they express our wide-eyed wonder at the grandeur and immensity of the starry expanse above our heads and, by implication, our appreciation of the littleness and brevity of human life.

No words like stage, platform, plaza or dais adequately conjure up these vast raised spaces that became such a feature of ancient sacred sites around the world. Tiananmen Square in Beijing and Red Square in Moscow give an idea of the scale of these places, but not of their use and purpose. Altar is a truer description, but this, in our times, has shrunk to little more than a table on which the hands of priests, not the movements of people *en masse*, perform ritual oblations to the gods. The great, elevated squares of the past were not built for parading soldiers but for the cumulative assembly of spiritual processions and dances. These would have looked as strange to our eyes as the hushed, white-socked movements of the priest-actors across the Noh theatres of Japan, the last sacred altars still in use for ritual performances. These stages are out of bounds to anyone who has not been ritually purified. For the same reason, Muslims remove their shoes and wash their feet and hands before they step on to the floors of their mosques which are, in effect, sacred altars under the dome of heaven.

The first ceremonial altars were built by flattening the peaks of holy mountains. An early example is the rock in the centre of Tushpa, the capital of the Urartian kingdom in Turkey; a later, much smaller one, is the carved mountain peak, the Hitching Post of the Sun, in the centre of the Inca city of Machu Picchu. The first temple of Solomon in Jerusalem was an extension of Mount Moriah, sacred to the Hebrews. It was destroyed by the Babylonians but then rebuilt and enlarged by Herod the Great using colossal blocks of stone, the size of which can be appreciated in its remaining lower tiers, now called the Wailing Wall, where Jews weep over the loss of their sacred site. When Jesus overturned one of the many moneychangers' tables

(Jewish worshippers had to use Hebrew instead of Roman coinage when making offerings) there could easily have been as many as three thousand people on top of the temple. The notion that they were inside it was a later misconception; the raised altars of the past needed no other roof than heaven.

One of these ancient ceremonial altars survives in something like its original form in the centre of the Forbidden City in Beijing. The city itself is rectangular, representing the earth oriented to the four directions. The walls that surround it are 7.9 metres high because air at that altitude was believed to be too pure for evil spirits to breathe. Beyond the walls is a moat representing the waters that encompass the earth. The sacred altar in the centre of the city is in the shape of the Chinese calligraphic sign for the earth, viewed from above. Up until 1912 the emperor lived in the north section of the city, at ground level, with his many wives, offspring, castrated male attendants and serving women. In his garden stood a boulder naturally specked with white spots in the configuration of the constellation of the Great Bear, or Ladle as it is known in China. On top of one high rock was a shallow pond that collected dew – the purest water of the world – which the emperor sipped to bring longevity.

The emperor began his official duties before dawn. He was carried in a throne along the Dragon Way, the cloud-decorated path that ran through the heart of the city directly north to south, up a series of ramps to the high central altar. Here the emperor divested himself of his mortal nature and was transformed into a god-like being. He wore glorious rainbow-hued garments and was borne aloft on clouds of multicoloured incense. Dragon spouts around the balustrades spurted water as he passed, intended, by simulation, to stimulate rain and symbolise the beneficence of the emperor's reign. He eventually arrived at the Gate of Great Harmony just at the

moment when the sun's rays broke over the eastern horizon. It was then that he announced his edicts, which his emissaries carried to the four corners of his kingdom.

The emperor's ritual journey from the cold north to the warm south, crossing the path the sun took from east to west, strengthened the central axis of the world and so maintained the harmony of the universe from which all goodness flowed. The primary job of the emperor was to maintain the balance of the state. He is now often caricatured as a terrifying dictator, but in fact he was more like an adjudicator. The most impressive hall on the central altar was a vast exam room, where he presided over the final selection of the highest-ranked mandarins.

Chinese justice was ruthless because it was based on a rigid perception of symmetry. No other sophisticated culture could have conceived of their punishment for a serious offence (such as stealing a horse): the convict stood upright and was sliced horizontally in two through his midriff (representing the division between earth and heaven). His still living upper half was then placed on a square tray (representing the earth he had offended) and carried through the streets until his still conscious, terrified twitching subsided, a process that could take ten minutes, much to the edification of the assembled masses.

When we visit the remains of the great, elevated altars of the past, we tend to imagine them as settings for dictatorships. They were certainly used for triumphant displays of military power, but then, in the days of visual warfare, the mere appearance of an army could be enough to put an enemy to flight. The ceremonies on these raised altars glorified celestial power, not merely physical might. The first conquering emperors were often surprisingly magnanimous. One of the earliest, Cyrus the Great of Persia, who presided over the whole of south-west Asia, from the Nile to the Indus,

decreed that no one should be forced to change their faith. This is the earliest known statement of human rights. Ashoka, the Qin emperor and Julius Caesar all tolerated differing beliefs, clan memberships and styles of dress across their Indian, Chinese and Mediterranean empires. These overlords concentrated their efforts on unifying weights and measures, coinage and length of carriage axles and in codifying laws, for they saw themselves as bringers of justice, not dictators in any modern sense. They were representatives on earth of the harmony of the spheres.

Justice found its most perfect expression in scales. A balanced arm was an image of the earth's horizon: when it was level everything was in harmony and peace reigned across the world. A king's main task was to dispense justice. Right up until the seventeenth century, each Mughal emperor climbed into huge scales to be weighed (wearing, it has to be said, the flimsiest silk garments) so that on his solar birthday his equivalent weight in gold, and on his lunar birthday his weight in silver could be distributed as alms to the poor. Gold must have amazed people who were lucky enough to hold a piece. It looked as light and bright as the sun yet you could feel its massive weight digging into your palm. Gold looked as if it were trying to rise and sink at the same time. That's why it was so often put in graves: to counteract death's downward pull and to rise again as the sun rose.

Scales are first mentioned in the Ancient Egyptian Books of the Dead, which were citations summing up people's lives. One compiled in about 1280 BCE for the scribe Hunefer shows him standing to one side looking on while his heart is weighed in the scales against a feather. The heart was believed to be the home of the soul; if it was pure and true, the heart would be lighter than the feather. There is a moment of tension as the balance weighs. The ibis-headed Thoth is poised to record the judgement. Ammut, the Devourer of the

Dead, stands by, his huge crocodile jaws gaping, ready to swallow Hunefer's heart if it sinks. But this time Ammut goes hungry. The heart rises. Hunefer has led a good life. The crimes which he hasn't committed are listed: he hasn't stolen, been covetous, killed anyone, damaged a grain store, lied, trespassed, practised usury, gossiped, committed adultery, had sex with a boy or abused a king. So he is declared Maa-Kheru, True of Voice, and is presented by Horus to Osiris, the resurrected god of Justice who had rid Egypt of cannibalism centuries before, introduced agriculture to the Nile delta, and disarmed all wild creatures with his tender affection.

The choices people made on earth, the paths their lives took, became important both to individuals and to states, where they were manifest in the progress of kings, in parades of subjects bringing tributes and in marching lines of soldiers. These are the movements of chess, a game developed in India at least four thousand years ago on boards imitating the flat, square earth traversed by a grid of lines. An ancient poem incorporated into the Chinese novel *The Three Kingdoms* reads: 'The sky's a curving vault / The level earth a chessboard / Where men their black and white divide / Disgrace or glory to decide.' The Chinese, having discovered the hidden force of polar magnetism, played their version of chess along the lines rather than on the squares. Chess charted movements on earth; it could be played as a game. Our overriding concern, however, was with the movements in heaven.

The great altar in Britain, Stonehenge, was in use for a thousand years, from about 2,500 to 1,500 BCE. It began as a timber circle, later made permanent with massive blocks of stone. Many of these were cut from a peculiar pillared outcrop of dolerite rock in the Welsh mountains. Dolerite has a bluish tinge and is dappled with white spots that look like stars. These megaliths, weighing between two and four tons each, were transported 250 miles, an

extraordinary achievement in those times. which indicates that building Stonehenge was a massive communal enterprise.

Countless theories have been proposed to explain the alignment of these megaliths. The most popular concept is that Stonehenge was used to celebrate sunrise and sunset at midsummer (a practice Druid revivalists claim to maintain), though some historians favour the idea that it was used like the Circular Altar in Beijing to encourage the weakening sun to rise again in midwinter. But none of these theories explains the fact that it was a wooden henge before, and the hewn tree trunks it was made of are unlikely to have created the same configuration as the stones.

All the interpretations to date could be mistaken, however – the consequence of facing the wrong direction, as Don Marcelino did in the cave at Altamira when he looked down, not up. The current theories about Stonehenge are based on looking across the ground, which is a modern, materialistic standpoint, not up to heaven, which was our ancient, mind-elevated perception. The T-pillars at Göbekli Tepe, the elevated plateau of the Nazca Lines in Peru and the Circular Altar in Beijing and all the great raised altars of the past suggest that the people who built Stonehenge would never have performed celestial ceremonies standing on the lowly earth. That would have been unimaginably insulting to the immortal beings, for it would have brought them down from heaven to bite the dust and tread in the dung.

Stonehenge was, most probably, a circular raised wooden altar, immensely strengthened by the addition of stone supports which enabled it to take the weight of thousands of worshippers who progressed towards it from the four corners of the kingdom it served – an ancient Mecca on stilts. Having journeyed as directly as they could from distant lands, the supplicants on reaching the altar rose up ramps or climbed stairs, and then perambulated round

singing prayers to the slowly circulating stars. An inscribed tablet instructs the people of Tushpa to worship on the rock-cut altar in the centre of their city four times a year: on the birthday of the king, on the date of his marriage, on the death of his father and on the day he went to war. Stonehenge might have served a similar, unifying role in the realm of southern Britain.

The horseshoe platform in the middle of Stonehenge would have been reserved for kings, the royal family, knights and high priests. As in Göbekli Tepe, this could have been the final resting place for a royal body, laid out to be burnt or to be fed to the birds. Here the cries of the circulating mourners would help his spirit rise to the stars. Royal births could have been celebrated here as well, for this was where celestial influences fell to earth. Stonehenge was shaped like a huge cup and ring mark, or the eye of the earth looking up to heaven. Old families in northern Britain, until the mid-twentieth century, lit bonfires on the tops of hills when a boy was born. The beacon often wasn't lit if the baby turned out to be a girl.

Stonehenge would have been an ideal location for coronations, the symbolic process by which a king was imbued with celestial responsibilities, as the circular, radiant crown was slowly lowered on to the dome of his head. The monarchs of England are still crowned on the Great Pavement in Westminster Abbey, a raised square dais, orientated to the four directions. It was laid down in 1268 CE and made of purple porphyry, green serpentine, yellow limestone and fragments of coloured glass arranged in exquisite orbiting patterns, a star mirror on earth. Of the many elaborate ceremonies that have been performed on this holy altar, only the stones remain.

The massive blocks of Stonehenge might well have been aligned to have some meaning in themselves, to allow rays from the rising and setting sun, when they streaked along at ground level, to

penetrate the circle's heart on occasions when particularly signifi-
cant ceremonies were to be performed at certain times of the year,
above all at each solstice and equinox. And the stones were surely
sacred in themselves, star-dappled pillars of dolerite that held up
the sky. But these magnificent megaliths are only the broken, frag-
mentary skeletons of a faith, not its flesh, still less its breath. These
ragged teeth give no indication of the chants that rose from the altars
they supported, calling to the circling, celestial lights of heaven, high
above the worshippers' heads, music for the eternal spheres, not for
the ears of mortals on the flat, square earth beneath.

Veil

Our next perception of the universe was triggered by something we couldn't see. Zoroaster, a priest who lived in Persia about three thousand years ago, argued that if heaven was our reward for leading a good life on earth, we had to be free down here to choose between good and bad. Free will separated us from the animals, who couldn't tell right from wrong, and placed us all on the same level with an equal potential to become saints or sinners. Zoroaster's world was flat and, for the first time, everyone, whether kings or peasants, men or women, stood shoulder to shoulder on the same level under the celestial dome.

The price of this new freedom and equality was a sense of loss. Free will cut us off from heaven. We must have come from there, for we alone among the animals had a grasp of what was good, but clearly we'd fallen from this state of grace because of some sin we'd committed in the past. The concept of guilt wormed its way into our spirit. All our suffering on earth was explained: life was a punishment, literally a death sentence, and each one of us was on our own,

left to make the best of it. The only hope we had was the gift we'd been given of free will, a drop of invisible starlight in our hearts and minds which we came to call our soul.

Souls were pure, translucent essences, as distinct from flesh, blood and bone, Zoroaster argued, as fire is from the wood on which it burns. His teachings were a moral system based on the worship of light and fire. It was the purity in the flames, he said, that made them rise to heaven. Cremation was outlawed among his followers because burning flesh would corrupt fire. The Zoroastrians left their dead to be eaten by vultures in round Towers of Silence built high on the tops of hills. A few of these are still in use in India, though their future is at risk since vultures are becoming increasingly scarce. The bodies lying in them were arranged in circles, children near the centre, then women, with men on the outer ring, an emulation of the rotating stars, the moon and sun, ranked according to the strength of their shining. Goodness and truth, Zoroastrians believed, made the human soul glow more brightly. In the world's first egalitarian schools, they taught their children the importance of truthfulness, alongside cooking and sewing for girls and riding and shooting for boys.

Belief in free will spread rapidly, but despite the Zoroastrians' attempt to promote a degree of sexual equality, old hierarchies persisted in most societies. Men increasingly came to accept that women had souls, and eagerly anticipated their attendance in heaven, but they didn't allow them free will. Women, until modern times, were considered to be instinctive creatures, nearer to nature, incapable of logical thought and rational judgement and therefore not fully responsible for their actions. Women existed on a lower rung, to be guided by and to obey their masters.

A thousand years before Zoroaster, the Silk Road began to thread its way across the dangerous and inhospitable deserts and mountains between China and Persia. The earth appeared to be

getting wider and wider, and where the land ended the ocean took over, disappearing into an unimaginable distance. The horizon seemed endless and – this was very mysterious – no matter how far we travelled, the sun never looked any nearer or bigger. We'd long before realised that the earth, unlike heaven, had no centre. But we'd discovered that we each had a centre within us, our free will that linked us invisibly to the upper realm. This new perception of existence was manifest in the philosophies and faiths that began to emerge more or less simultaneously around the world about 2,500 years ago.

The assumption that all of us were doomed to lead brief, desperate lives on a flat earth where nothing was permanent, under a domed heaven that radiated eternal bliss, underpinned the teachings of Taoism and Buddhism, Confucianism and Platonism, and Judaism with its later offshoots, Christianity and Islam. These all expounded different theories about how people could get from this world to the next. But, with the notable exception of Confucianism and, to a lesser degree, Platonism, these philosophies taught that the primary aim of life was to leave it. They all presumed that the elevation of our souls could only be achieved by our own efforts. A new purpose and direction had been given to our lives and this affected how we interpreted the world we saw around us.

Starlight still shone out of our eyes, but the soul itself was invisible. You couldn't see free will any more than you could see truthfulness (though most parents cling to the hope that they can see it in the eyes of their children). We came to realise that truth was hidden from us. But since truthfulness and the goodness that flowed from it became the most important things in our lives, our passports to eternal happiness when we died, we came to see the whole world in terms of veils that hid divinity from our gaze.

Blue sky veiled the stars, the spirits of the dead, when we woke to our daily lives. But this glorious, azure hemisphere revealed

to us a greater, subtler truth: the relationship between heaven and earth. At its zenith the sky was a deep clear blue, but as it descended towards the horizon it became lighter and lighter until it turned into a white wall of mist. There was always a haze in the far distance; even the mountains were shaded with the blue of the sky. Between heaven and earth, between our eternal life and our mortal life, there hung a veil. Our lives were meant to be bathed in mystery.

Everything in our lowly, earthly existence was doomed to end in death. Even sight, the most penetrating and far-reaching of our senses, fell short. When we watched a man walk away across a plain, he became increasingly indistinct and then disappeared, though we knew he must still be there. We couldn't see the end of the world simply because our sight was too weak to reach that far. Ships, when we built them with tall enough rigging, apparently behaved differently. When they sailed away, they appeared to sink down over the horizon. This couldn't be explained by the curve of the sea, which everyone knew was flat. It was logical, instead, to suppose that sight, flying like an arrow, dipped as it lost its strength. The wonder was that we could see the stars, sun and moon and the five wandering planets even though they must be further away than anything, because they rose and fell beyond the ends of the earth. These heavenly bodies must have helped us see them by lifting our feeble eyebeams up into the pure, clear atmosphere of eternity, for we saw the sun and moon sharp-edged, like circles seen up close.

It was understandable that there should be a limit to our sight's reach, just as there was to our hand's stretch. But if you brought your finger very close up to your eyes you could see through it, even though you knew it was still there. We couldn't see things that were very close to us or very far away for the same reason that we couldn't see the middle of the world or the end of the world: we weren't meant to see them. The ultimate truth was hidden from us. The moon taught us to accept our fate. She was born, grew and died

as everything did on earth below. She was our mother and was kind to us and gentle. When she rose, large and close, she kissed the hill, as a mother kisses the brow of her child as it falls asleep. She understood our suffering and could intercede for us with the fierce, unchanging sun, who obliterated her glow when he appeared. When she was full, the moon gathered our dying souls to her bosom and lifted them up to the celestial realm.

A delicate, pale silk banner, wafting in the breeze, was carried at the head of the funeral procession of Lady Dai, a Chinese noblewoman who died in 168 BCE. The painting on it showed her soul drifting up from the flat earth, above the swirling monsters in the sea beneath. She asks two wandering spirits the way and is guided through the clouds up to the vault of the sky. There waves of incense waft her higher to heaven where the sickle moon and the sun reign. The banner was laid in her coffin before it was sealed in her charcoal-lined grave, which is why this extremely fragile textile survives.

There were veils all around us: mists veiled the mountains and daylight veiled the stars, and there was a little veil of flesh, the virgin's curtain, on the bed of men's desire. The sun's light veiled the moon; so men ran the daily affairs of state, their faces uncovered, while women were relegated to private, domestic roles within the home. Women were not allowed to speak when men's business was discussed. The empresses of China sometimes insisted on having their say, but even they were only allowed to make comments from behind a screen. When women appeared in the open air, they had to have their faces covered, hidden as the moon is during daylight hours. This peculiar practice became widespread around the world, especially in Hindu, Buddhist, Christian and Muslim societies.

In desert countries, veils kept dust and sand from blowing in both men's and women's faces and shielded skin from the burning sun. But in other cultures veils came to be associated solely with women. The higher up a lady was on the social scale, the more com-

pletely she was covered, to protect her from vulgar eyes and to keep her flesh pale. In Japan and Korea, aristocratic ladies' veils blossomed into elaborate, starched gauzes that encased their whole bodies like gossamer wings, strange, ethereal beings moving through the crowds. These cocoons of rare exotic butterflies would emerge only for the eyes of their husbands, not for public scrutiny. Brides originally wore veils to proclaim their virginity and fidelity. Showing one's hair in public was scandalous, the mark of a prostitute. Hair was earthly and grew in unseemly parts of the body. Every strand of hair on women's heads was religiously hidden behind a veil, brows became pure and domed like heaven, and eyebrows were plucked.

Seeing became a manifestation of free will; it was an emission from the eye that could do good or ill. Women wore veils to protect themselves from the evil eye and from lustful, envious gazes that could sully the purest flesh. The emperor of China wore a hat shaped liked a scholar's mortarboard, a close-fitting crown with a flat, rectangular top, representing heaven and earth, the compass of all learning. Two curtains of tiny beads hung down at the back and in front, shielding him from evil glances from behind and protecting his subjects from the divine force of his glare. Veils became the reality of our lives.

Buddhism has a name for the illusion that is this world: the Veil of Maya, the cloak of unknowing that Buddha's mother kindly cast about us to prevent us remembering the pain of our birth or foreseeing the agony of our death. Her son Siddhartha Gautama began life in a world of veils. His father, a wealthy Indian aristocrat, wanted to shield him from any sight of pain and brought him up in four palaces, one for each season, to give Siddhartha the impression that nothing aged or died. When Siddhartha travelled between them he was carried in a curtained palanquin but once, when he was twenty-nine, the curtain slipped and he saw, in sequence, a crippled old man, a beggar covered in sores and a corpse lying in a ditch. He

never went back to his palaces, but dedicated his life to finding a way out of suffering.

Siddartha consulted many Sadhus, the Hindu wise men who went naked, dressed by the sky, sprinkled in ash anticipating their coming death, but none of them could show him the way. In despair, he resolved to starve himself to death. But as he was about to slip into unconsciousness, he overheard two passing musicians. One said, 'If you tighten the string too tight, it will snap; if you loosen it too much, the instrument won't play.' He realised that there might be a middle way to end suffering, through meditation. He lowered his eyelids until the outside world was almost completely veiled from view, and turned his gaze inward to discover the path to Enlightenment. It took him thirty days. Siddhartha, transformed into the Buddha, instructed his disciples to be the light of themselves. Our inner souls enable us to reach the stars.

The new philosophies of the Far East all grew from the assumption that the truth is veiled from us. The founder of Taoism, Laozi, who lived around the sixth century BCE, taught that everything on earth is in a state of flux, endlessly melding between the Yin and the Yang – day and night, life and death, up and down – and that there was nothing we could do about this except try to find a way out. One Taoist teacher pointed at the moon and upbraided his pupils for looking at his finger. The way that could be seen, the way that could be told, wasn't The Way, for that was beyond our understanding.

The sixth-century Chinese philosopher Confucius believed people had an instinct to be good, but didn't concern himself with its origin in heaven. He argued that if you didn't understand life, you couldn't begin to understand death. He thought that everyone had the right to live under a just government, but though their rights were equal, their abilities were not. Confucius's idea led to the establishment of the world's first meritocracy, founded on an examina-

tion system that was theoretically open to all men, and in some periods actually was, though never to women. Examinations were eventually elevated to the highest level in society, presided over by the emperor, the Son of Heaven, on the sacred altar in the middle of the Forbidden City in Beijing.

As a relaxation from the business of government, the Chinese mandarins painted. This mighty, ancient, enduring culture found its quintessential artistic expressions in the most evanescent and flimsiest of all media, watercolour – veils on silk and then on paper, a support the Chinese invented in their search for cheaper, more easily manufactured flat surfaces on which to capture fleeting images of nature and calligraphic poems, which were pictures as well as words. Images of mountains melting into clouds, waterfalls tumbling into light-reflecting lakes, birds fluttering among bamboo canes and cranes flying over rolling waves were hung around their walls to remind these weary officials of the transience of the world.

The archipelago of Nippon (modern Japan) lay off the coast to the east of China. The name means 'land of the sun's birth', the most easterly reach of the world. The indigenous Shinto faith, which had it beginnings when the world was conceived of as a living being, embraced the new, veiled world view by transforming the country into a body graced with beauty spots. Snow-capped mountains, cherry blossom and trees in autumn colouring were believed to be gateways out of the floating world, into eternal divinity beyond. Particularly entrancing views were framed by Torii gateways – huge, open, stylised vulvas, painted blood red. The Japanese world view remained frankly sexual, if elevated and abstracted. These arches were apertures leading to a spiritual life.

Japanese houses were built of veils, thin sliding panels covered with paper or cloth, called *fusuma*, many of them in wealthier houses painted with images of time passing in nature, birds migrating, wind blowing through reeds, mist rising. The world's first novel,

The Tale of the Genji, written in the eleventh century by Murasaki Shikibu, takes place in a world of screens. A cat knocks one over, enabling a young man to spy a woman above his station. Illicit love erupts and tragedy ensues. The Japanese developed an unrivalled sophistication in two-dimensional design, an exquisite asymmetry on hanging scrolls, opening fans and folding screens. Appearances were a veil which, when lifted, as a lover lifts the veil of his betrothed, allowed one to glimpse a beauty that had been hidden. The great Noh dramatist Seami Motokiyo defined beauty as a white bird flying past with a white flower in its beak, a chance occurrence in nature that enabled you to glimpse wonder beyond the ordinary.

The great new faiths – Buddhism, Judaism, Christianity and Islam – began without any art at all. If everything in this world was transient there was no point in trying to make any lasting images of it and, worse, these would be an earthly distraction. The divinity you had set your heart on attaining was above this world and invisible. If the soul and free will were veiled from our eyes, it was logical to think that god and heaven were also hidden from our perception. The Jews claim, with some justification, to have been the first people to worship a single, all-powerful but invisible god, Yahweh. He made Abraham a promise that if he worshipped no other god and was circumcised, he would ensure that Abraham's descendants would be as numerous as the stars in heaven.

The idea of a god you couldn't see was baffling to non-Jews. When the Roman general Pompey tore apart the curtain masking the Holy of Holies, a small shrine on the Temple in Jerusalem, he was baffled and amused to discover that the chamber behind it was empty. But it was the veil itself that was important in Judaism, not because it hid anything but because it symbolised what you couldn't see. The cloth was coloured purple, a blend of blue and red, the colours of the sky and blood. Purple was also the colour of both

edges of the rainbow where it faded into the dark blue storm clouds around it – the bow that Yahweh had set in heaven as a covenant to his people, the promise of hope when the sky darkened before an approaching storm.

Jesus was a Jew, and his images of human souls are of tiny, ordinary things almost too small to see: a mustard seed, a dose of yeast, a grain of salt – no, merely the taste of the grain of salt, which was invisible. His world, like Buddha's, was flat and wide, and everyone stood on the same level on it, equal under heaven. The first Buddhists and Christians didn't create images, because they believed that everything they could see in this world was a deception or, worse, sinful. But both these faiths were adopted by emperors and for much the same reasons. Ashoka espoused Buddhism in India, and Constantine Christianity in Byzantium, because they wanted to appease the growing numbers of poor who were attracted to these humble, non-materialistic beliefs and to espouse a faith that was not clan-based or, at least to begin with, sectarian.

Though the Buddha was later depicted attaining enlightenment under the Bodhi, the sacred fig tree that represented the Hindu *axis mundi*, and Christ was shown perched on top of the Tree of Jesse, both religions in fact broke free from the idea of a family faith. Anyone could be converted to Buddhism or Christianity and this chimed with the wishes of these emperors who wanted to appeal to a wide cross-section of their populace. These were the new religions of the age of the veil, instructing their followers to quit the world, 'to render unto Caesar that which is Caesar's', and give free reign in earthly matters to dictators who espoused their cause.

Ashoka unified India by using the Buddha's vision of goodness above and equality below. He had thirty Pillars of Righteousness and Cosmic Law and Order erected across his empire, each one 17 metres high and topped with four lions facing the four directions,

a symbol still used widely to represent India. The obelisks were inscribed with texts promoting the principle of dharma, the goodness that rises within you to heaven, which, if nourished, brings kindness, generosity, truthfulness, purity and gentleness into the world. He also created the first massive monument to Buddhism. The Great Stupa at Sanchi, which covers relics of the Buddha's bones, is a colossal solid hemisphere symbolising heaven overarching the flat earth, ringed with terraces for worshippers to emulate the circling stars. Four gateways, decorated with scenes from the Buddha's life, lead into the site from the four directions. Like Christ, Buddha was believed to have walked on water – the elusive meridian of existence. But in these early purist days, he couldn't be shown as a person, so he was depicted as a block of stone floating magically on the waves.

The Byzantine Emperor Justinian built the first massive monument to Christendom, the Hagia Sophia, shrine to the Holy Wisdom of god, in Constantinople. As with Sanchi, it took the form of a dome, but one that arched over the flat earth – a dome that could be entered and that sheltered all the worshippers beneath. The temple of Christianity was no longer open to the heavens, for both the blue hemisphere by day and the stars at night were perceived to be veils that hid god's throne from our unworthy gaze. The builders of Hagia Sophia weren't merely trying to solve the immense technical problem of spanning a vast, public space. Still less were they consciously struggling to evolve a new architectural style, which later ages would call Byzantine. They were attempting to express the wonder of god's created world, showing how the circular sky fitted on top of the rectangular earth. Where they met were walls and arches covered with shimmering gold mosaics, the veils of illusion that surrounded us all. The Hagia Sophia remained the largest domed building in the world for a thousand years.

The Muslims who conquered Constantinople in 1453 were so impressed by this church that they adopted it at once, and used it as a model for many subsequent mosques. Early Christian and Islamic buildings took the same form because these faiths shared the same world view. Islam sprung mainly from the clan faith of Judaism and shared its belief in an invisible god. With superb political skill, Mohammad unified the warring Arab tribes by preaching against idolatry. If a god could be seen it was a false god. Like most ancient people, these desert tribes had worshipped trees, rivers and hills, rocks and wells. For centuries, they had shared a collective focus of worship, the Ka'ba at Mecca, which was centred on a large, black meteorite which, it was believed, had fallen to earth from heaven and had the magical property of being able to float on water.

When Mohammad made his triumphal entry into Mecca in 630 CE, he headed an army of 10,000. The Ka'ba was then packed with statues and paintings of many gods and goddesses, including images of Jesus and the Virgin Mary. Mohammad had them all destroyed except, reputedly, the image of the Virgin, though this too was lost when the temple was burnt to the ground fifty years later. The Ka'ba, now a black-veiled, empty Holy of Holies, remains at the heart of Muslim worship. In one corner, facing east, set in a silver mount shaped like a vulva, is the Black Stone. Muslims are still required to make the pilgrimage to Mecca, the hajj, and walk round this stone, Islam being the only faith that maintains a belief in the central axis of heaven reaching down to earth.

Like Buddhism and Christianity, Islam became a missionary religion, welcoming all converts, for Allah's throne was believed to be as wide as earth and heaven. It spread its message primarily by sounds, not sights, the five daily calls to prayer from tall minarets that pierced the sacred level above our heads. Representational art

was largely eschewed in a religion that was founded on the belief that god was invisible, idolatry sinful and the world itself an illusion. But artists in Islam discovered in the ribs of feathers, the veins in flowers and the scales of fish a hidden, abstract beauty that they believed reflected the drift of stars, and they drew these patterns, interlaced with the words of god, in tiles and tracery on the walls and arched ceilings of their mosques and in the coloured threads of the carpets on their floors, patterned arabesques squeezed into the thin surfaces of veils.

The walk-in epic poem that is the Alhambra in Spain praises Allah's hidden presence in the world. Its glazed tiled walls turn shaded corners into pools of light with star petals overlapping like coloured eddies crossing in water. This two-dimensional divinity flowers into three dimensions in the vaults, high-arching honeycombs, tiers within tiers of ever higher, smaller, inner peaks, once painted sky blue and cloud white, side-lit by narrow stained-glass lancets rising within its domes. Your eyes are drawn up into this myriad of receding complexity, forever seeking a highest point, but that remains indeterminable because heaven is higher than mortal eyes can reach.

A wall of red and white sandstone screens your first view of the Taj Mahal. It is visible only through a narrow archway, decorated in its peak with an exquisite lacework of stars. The pearl-white building hovers in the distance, suspended on the horizon against the pallor of the sky. It appears to have condensed out of the veil of mystery that surrounds the earth. The building seems insubstantial yet you can see that it's immense. You involuntarily draw in your breath, in surprise and awe. Then you notice that the shaded arches in the building's sides, beneath the great swelling dome, make it look as if the Taj is holding in its breath as well. A hush pervades, despite the pushing, noisy crowds.

The Taj was built by Shah Jahan, the fifth Mughal emperor of India, for his wife Mumtaz Mahal, who died giving birth to their fourteenth child. It is a resting place on the lintel of paradise, rather than a tomb, where she can lie at ease until Allah descends in his throne on the Day of Judgement and raises her to heaven in his arms. Although the poet Rabindranath Tagore, with Victorian sentimentality, compared it to 'an eternal teardrop descending from heaven on the cheek of time', it in fact represents, in its white, bud-like form, the drop of divine semen referred to in the Koran: 'How stubbornly man denies the truth! How often does he consider out of what substance God creates him? Out of a drop of semen He creates him, and then determines his nature and then makes it easy for him to go through life; and in the end He causes him to die and brings him to the grave; and then, if it be his will, He shall raise him again to life.'

Three world views culminate in the Taj Mahal: its peak and descending domes are carved out of a perfect pyramidal shape, an image of a centred royal hierarchy sustained by the Shah's beloved wife; it sits on a square, raised altar suspended between earth and heaven; and it is seen against the misty distance, representing Islam's new vision of a wider, more open world, where everyone, even queens, are equal under a god who can't be seen. The Taj Mahal shimmers on the edge of our perceived existence, a vision in marble of the moon rising through the mystery that is our earthly life, the last, most glorious manifestation of the era of the veil.

Through a Glass, Darkly

The discovery of the scientific approach to seeing – the accumulation of knowledge by the systematic observation of effects and causes, resulting in theories the truths of which can be tested by repeated experiments – has gradually and irrevocably transformed our perception of everything. Science has eroded all our earlier, presupposed, enchanted world pictures, though shadows of many remain in our minds. It has replaced these with an enveloping and inner darkness of unimaginable vastness and minuteness. We exist, briefly, somewhere between the macrocosm and the microcosm and, even more peculiarly, know that we do so due to our unique and so far inexplicable self-awareness.

After the beginning of science it was no longer possible to think of common-sense world pictures in terms of single all-embracing images, of a body, a tree, a pyramid, an altar or a veil. We began to learn to live in a cosmos containing myriads of ever-extending and increasingly disorientating realisations. The 2,500 years of

human history from Ancient Greece to the present can be divided into the period before Columbus's journey and the chance discovery of the telescope and microscope, when our understanding of the universe remained theoretical, and the modern period when scientific theories became inescapable realities. The final three chapters of this book have been divided in this way, the first pre-Columbian, the second and third telling the story of the European Enlightenment and its impact. These three chapters cease to paint pictures of overall visions, but instead give glimpses of attempts that have been made to create coherent visions which have struck a chord with people living in the midst of an increasingly inhumane and darkening universe.

Science had a singular beginning in the history of humanity. Hominids had been thinking technologically since they first honed tools, harnessed fire and stitched clothes. As *Homo sapiens*, we began to work out ways to channel water, forge metal, transport weights, rear animals and cultivate grain. But the curiosity-driven objective study of the natural world, without any practical purpose in mind, was a very late and unique development in our history. It only became possible, of course, when we had the leisure to muse. But, more than that, it owed its origin to a radical shift in the way we saw the world.

The people who began to indulge in the rarefied activity of pursuing knowledge for its own sake were called philosophers at first, scientists much later. Their approach was startlingly original: they dared to think that the world might not be an unfathomable mystery or a veil of illusion that had to be bypassed in the search for the eternal truth above. Instead, they considered that nature was worth examining for itself. They had the extraordinary effrontery to assume that the transient world they lived in could have permanent truths lying buried within it – the laws of nature, which could

be discovered by systematic examination and experimentation. They put their minds to this task with relish and changed, seemingly irreversibly, the way we saw the universe.

It all began 2,500 years ago in Ancient Greece, a scattering of little islands and small independent city-states. None of these was big enough to sustain a controlling hierarchy, but each male citizen contributed to the community by means of different, experimental systems of democracy, many of which were bizarrely elaborate. Men spent hours hearing and making speeches for and against proposals on countless issues before voting on them. One result was that the Greeks became brilliant debaters. The small island of Miletus, in particular, buzzed with new ideas. One of its merchants, Thales, who had made a small fortune trading in olive oil, became the world's first philosopher and was generally regarded as having his head in the clouds. A children's ditty became popular around the archipelago: 'Thales fell in a well, fell in a well, fell in a well.' It's quite possible that one day he did as he strolled along lost in thought, but then he had a lot on his mind, for he was trying to work out how everything fitted together.

Thales tried to make sense of things you could sense, and since the gods were beyond sense they could safely be left out of his calculations. This was Thales' daring assumption. He formulated the world's first consciously constructed world picture: he thought the earth was a flat disc surrounded by water. When water arched over it, it fell as rain. The sun, moon and stars were burning balls of vapours sailing through the waters around and above us. His friend and follower, Anaximander, thought the world had begun as an egg-shaped sandwich, with earth, being heaviest, at the bottom, water in the middle and mist on top, surrounded by a sphere of fire. The fire had then heated the water, some of which evaporated, and the dry land had appeared. At first the only animals were fishes, but

some of these grew legs to live on land, including humans. (He was remarkably right about this.) The mist grew thicker as more water evaporated, making the sky. The sun, moon and stars were holes in the sky through which we could glimpse the all-encompassing fire.

A debate had been ignited around the archipelago, and the new philosophers wrote poems and excitedly discussed their ideas. Anaximenes of Miletus was fascinated by an unaccountable phenomenon: if you blow on your hand with your lips pursed, your breath feels cold, but if you do the same thing with your mouth open, it feels warm. Mist at its hottest and most rarefied was fire. When it grew cold it condensed into water, and when it got colder and thicker, he thought, it turned into earth. He proposed that mist was the unifying substance of the universe, the turning point between hot and cold, between life and death.

While dissecting animals, Alcmaeon of Croton discovered the optic nerve. This led him to the conclusion that it was the brain that saw, not the eye itself, which raised the extraordinary possibility that the brain could see something that the eye couldn't. Empedocles, who lived in Agrigentum in Sicily, watched a girl playing with a *clepsydra*, a glass funnel used to lift liquid. She put her finger over the spout and pushed the funnel with the air in it down into the water. Air was made of something you couldn't see! Empedocles went on to think that a *clepsydra* explained how breathing worked. The writings of the first, mostly anonymous doctors, whose works were collected together and attributed to Hippocrates, thrill the reader with their excitement and impatience at their discoveries. One wrote that if the mind could see what the eyes could not, it must be possible to diagnose diseases inside the body by examining urine and faeces.

Another doctor wrote that 'our present ways of living have, I think, been discovered over a long period of time. The ancients

boiled and baked until they adapted raw food to the constitution of man.' Wine and bread hadn't been handed down as recipes by well-meaning gods, but had been developed by us through trial and error over time. We had free will and therefore could improve our lot. What we had or hadn't done in the past became significant. Herodotus, the world's first historian – and still one of the best – wrote a remarkably even-handed history of the Greek and Persian wars, in an attempt to discover what had caused them. Human folly emerged high on the agenda. His is one of the world's first modern voices, for the gods had no place in the story he told.

Aristotle tried to draw the threads of all this new knowledge together. He became tutor to the young Alexander the Great, and the two suited each other because both wanted to conquer the world, Alexander territorially, Aristotle intellectually. Alexander reached deep into India, but his army mutinied and refused to go any further. He was only 34 when he died on the way back, bitterly disappointed that he hadn't reached the ends of the earth. Aristotle had died the year before, equally saddened; although he had established all the main categories of philosophical enquiry – biology, botany, physics, anatomy, physiology, mathematics, astronomy, geography, mechanics, music and grammar – he realised that his understanding of the world was only just beginning. Most disturbing to him was the realisation that events in nature were not causal in the way he'd expected. He put it simply: 'The rain doesn't fall in order to make the grass grow.' This was a startling revelation: the world hadn't been made for any particular purpose, far less for a human one. From the very beginning science began to reveal a darkness in the world about us.

Aristotle's follower, Theophrastus, observed that flames on green logs burned red and suggested that the sun didn't die in a pool of blood, but owed its red colour at sunset and dawn to damp air.

Heraclides made the startling proposal that it wasn't the stars that were turning: we were. Aristarchus went further: he thought the earth and planets were going round the sun. The moon received its light from the sun and changed shape due to the earth's shadow falling across it. Eratosthenes worked out that the world must be a sphere and went on to calculate how big it was by observing the length of a shadow cast by a stick at noon on the summer solstice at Alexandria, knowing that at Syrene (now Aswan) at the same time a stick cast no shadow. He measured the distance between the two cities, extrapolated the implied curve and estimated that the earth was 250,000 *stadia* round (a *stadion* was the length of a Greek foot race, 180 metres). He was only 100 kilometres out.

These extraordinary revelations had little impact because they remained theoretical and, anyway, the theories cancelled each other out. The writings of Parmenides are known only from a fragment of a long poem, *On Nature*. He argued that since that which is not cannot, by definition, exist, there can be no void in nature. There are no gaps, everything is continuous; all is one. Things that appear to us to be differentiated, such as rocks and air, water and fire, sound and silence, are merely projections of our own illusion-bearing perception. Although this thought is beyond human perception and strictly non-thinkable, it became the foundation for that aspect of subsequent scientific enquiry that assumes that the mind can transcend all subjective, experiential ties in its search for ultimate truth.

Democritus, from Thrace, believed the void must exist. He proposed that since air had substance, it must be made of things that were too small to see, and he thought this could be true of everything. He proposed that the world was made of tiny atoms, each of which had a different shape and texture and was in perpetual motion: craggy atoms created rocks and acrid smells, smooth atoms created water and sweet tastes, fuzzy atoms created air and fire. He

believed that the void between them must be unchanging. The atoms also remained unchanging, though they were always moving. He conceived an eternal, infinite, uncreated universe in which nothing was lost or gained.

Democritus had few followers, but Epicurus was exceptional. He argued that there was no afterlife. Death was just the dissipation of atoms. The silliest thing we could do was to waste our life worrying about what came after, because nothing did. He taught that we couldn't avoid suffering, but could alleviate it by leading a life of pleasure, eating and drinking well in good company, in a delightful environment. His school was his garden. Over its entrance was inscribed: 'Stranger, you do well to enter, for here our highest good is pleasure.' Everyone, including women and slaves, was welcome: he was one of the world's first true egalitarians.

Down-to-earth optimism gleams through every line of the epic *On the Nature of the Universe*, the life's work of the Roman poet Lucretius, Epicurus' most dedicated admirer. His poem is a great hymn to common sense: 'The reason why mortals are so gripped with fear is that they see all sorts of things happening on the earth and in the sky with no discernible cause, and these they attribute to the will of a god. . . . This dread and darkness of the mind cannot be dispelled by shafts of day but only by an understanding – the shafts of thought.' So he wrote his poem to 'loose the tight knots of superstition and shed on dark corners the bright beams of my song'.

Lucretius did his best to explain the appearance of everything. He favoured the idea that the sun died burnt-out every night and was re-formed afresh every morning. 'So it is related that from the heights of Mount Ida at daybreak scattered fires can be seen in the East coalescing into a ball to form a single sphere.' This was credible because people at that time believed that the sun was the size that it appears to be. Regarding the origin of life, Lucretius believed

nature first produced monsters that did not have the cunning, speed or prowess to protect themselves and satisfy their needs, and so died out. 'For it is evident that many contributory factors are essential to the reproduction of a species: first, food supply; then some channel by which the procreative seed can travel outward through the body when the limbs are relaxed; and then, in order that the male and female may couple, they must have some means of interchanging their mutual delight.' He believed 'the pleasure of sex is shared' and wrote beautifully about the power of sexual attraction.

He went on to wonder why every creature was like its parents, yet everything individually distinct. 'Here is a familiar sight: incense rises on an altar. A sacrificed calf falls to the ground, blood spurting everywhere. But its bereaved mother roams the glades, scanning the ground for the twin-pitted imprint of those familiar feet. She pauses and fills the leafy thickets with her complaints. The sight of other calves in the lush pasture is powerless to distract her mind or relieve it of its distress. So obvious is it that she misses something distinctive and recognised.'

Ancient Greek and Roman culture was founded on an awareness of human individuality. The Greeks became famous for their painted portraits. None survives, but many Roman ones do. They depicted wrinkles, crow's feet and frowns, what people saw when they looked in the mirror, their careworn struggle through their time-allotted slot. Even when Rome's radical republicanism reverted to an older hierarchical system, their emperors remained personalities, some larger than life. By no means all of them were monsters. One can still look into the face of Marcus Aurelius – one of the most respected and magnanimous of emperors – and see a totally believable, troubled, sensitive individual, as he sits high on his horse on the Capitoline Hill in Rome. He'd wanted to be depicted thus, because, as he wrote in his *Meditations*, 'the soul defines the face'.

This was an age of reflection. For a brief period in the history of humanity, many people were content to look into their own eyes as in a mirror and leave the bigger questions, outside the frame, unresolved.

A similar awareness of individuality was dawning at the same time in China. Confucius, like Epicurus, concentrated on the here and now. 'Why,' he asked, 'should I try to understand heaven when I don't yet understand earth?' Since, he argued, you couldn't be assured that your good deeds would lead to good, you had to do good for its own sake. Morality was the goal of man, not heaven. Confucianism eventually took root within the ancient Chinese imperial, ancestor-worshipping system, and became the moral code for a culture that lasted 2,000 years. Individuals were responsible for their behaviour and individuality was an essential ingredient of life. The greatest expression of this reality so far discovered is the First Emperor's terracotta army. There will be 7,000 of these warriors when they are all finally excavated. Their armour and bodies were cast in moulds, but their faces were individually modelled and painted. Each one is subtly characterised; none is a caricature. This is an army of individuals, not an oppressive dictator's identikit pawns. Each soldier has a life of his own that can be read in his face, and as such the terracotta army is one of the most extraordinary artistic achievements of any age.

This battery of individuals defended an ancient hierarchical system, the pinnacle of which was the emperor, believed to be the son of heaven, lying in state under the immense pyramid which surmounts his tomb. It is possible that the dead emperor's chamber is still intact and, if archaeologists can find a way of entering it without damaging its contents, this sepulchre will make Tutankhamen's tomb look like a broom cupboard. The historian Sima Qian, writing a century after the Qin emperor's death in 210 BCE, described what

the tomb was like inside, and scholars think his description is likely to be largely accurate. There was a city with palaces and towers filled with treasures, rivers of mercury and a sea that appeared to flow. The heaven which arched overhead was hung with burning lamps representing the stars. Crossbows were rigged with arrows ready to shoot anyone who tried to break in. The Chinese world picture of a flat world surrounded by water lying under heaven with an emperor at its centre had been recreated underground, defended by a vast army of individuals.

While the early philosophers of Ancient Greece discussed the theories that they were living on a spherical, spinning world orbiting around the sun, and that everything was made of jiggling atoms, the vast majority of their fellows still thought they were standing on a flat, fixed earth under the starry dome of heaven. Their world picture was very similar to the Chinese one, except that collectives of individuals ran their states, not a single celestial lord. These collectives allowed individual philosophers to express their opinions, but they remained marginal to the views of the majority.

The greatest monument in Ancient Greece, the Athenian Acropolis, was a sky altar set on a high rocky outcrop in the heart of the city. Standing on it is still an extraordinary experience, with the modern city dwarfed beneath you, and the ring of mountains on the horizon to the north, east and west opening to the straight line of the sea to the south. You feel you are standing on top of the centre of the world, as if on the pupil of the earth's eye gazing up to heaven. Two thousand years ago the Acropolis was crowded, as Hindu temples are today, with shrines decorated inside and out with vividly painted sculptures and murals. The prime building among them was the Parthenon, which contained within its gloomy interior a gigantic statue of Athena, the mother goddess of the city below, made of gold and ivory, towering above a pool which reflected her

monumental glory, and kept the air moist to stop her ivory flesh from cracking. She was a Mount Kailash, Parvati and Venus of Willendorf rolled into one.

The temple closest to the spirit of the Parthenon still in ritual use today is at Shravanabelagola (the name means White Pond of the 22nd Lunar Mansion) in south India. It stands on a hill above a square artificial lake and contains within its enclosure, open to the sky, a colossal naked figure of Gomateshvara, a saint of Jainism who stood motionless for so long while he was meditating that creepers grew up his legs. Every twelve years, priests bathe his whole body in sweet, sacred unguents and decorate it with flowers. The Athena figure in the Parthenon was similarly celebrated every four years, her face being ceremoniously unveiled and veiled again, for a young girl, surely a virgin, is depicted carrying a folded cloth in the procession shown in the frieze.

The sensuous dark interior of the Parthenon was in extraordinary contrast to its exterior built of flawless white marble quarried from the nearby Mount Pentelikon. Apart from the painted carved reliefs in the pediments, metopes and along the narrow frieze, the temple rose stark white into the brilliant deep blue Mediterranean sky. Its form represented the shape of the known world – a flat-based, elongated rectangle, because the Greeks thought the world spread further along the east–west axis than it did to the north and south. The temple's four sides were constructed of rows of identical, elegantly proportioned, regularly spaced, free-standing, fluted columns. These evoked the pillars at the ends of the world that held up the sky, where the gods dwelt.

The colonnade around the Parthenon was not a barrier, a wall at the end of our understanding, but an expression of lightness and openness. With hindsight, it evokes the semi-permeable cell walls that later scientists discovered to be essential to the structure

of all life forms. The Ancient Greek perception of the world was orderly and measured as far as they could see, but it was not enclosed; there were mysteries beyond the pillars that they couldn't understand. And they were acutely aware that human perception was flawed. They built the base, inner walls and columns in a configuration of extremely subtle arcs to correct our natural inclination to see straight lines as curves. The building is an illusion of rectitude, an evocation of perfection in the mind's eye. This is why the Parthenon is such a hauntingly beautiful image of human consciousness. Its brilliant, stripped whiteness is the white of a skull, but it is also the white of an eye. This temple, set high on the brow of a hill, was a hymn of praise to eternal beauty after death and to our ability to glimpse it while we are alive.

The Parthenon faced due east. The frieze that ran round it, high up behind the stately colonnade, celebrated the dead heroes of the battle of Marathon, when the Athenians had defeated the invading Persians. The soldiers at the west end, at the moment when the sun has set, hurry to buckle their armour and leap on to their horses. Then they gallop along the sides of the temple, racing east to catch up with the sacrificial procession in front, for everyone has to be present when the first rays of the newborn sun break over the horizon and reach into the dark temple to revive the sleeping Athena within. At that moment Hera, enthroned in the eastern pediment, lifts her veil to reveal her naked body to her husband Zeus. In heaven, as on earth, connubial bliss and conception begin again each day at dawn.

Between the temples on the Acropolis, under the shady olive groves, stood dozens of life-size statues of naked youths on plinths, life-like portraits of the heroes of the games. The ones carved in marble weren't white, but had flushed cheeks, red lips and rosy nipples, and were painted all over with warm tints of flesh. Those cast in

bronze had long eyelashes fringing eyes made of coloured glass. Nudity was admired and praised in Ancient Greece. A man wasn't considered truly naked unless the head of his penis protruded beyond his foreskin. At the games and in the baths, youths wore only long, coloured ribbons tied round those parts that had earned them special praise, such as a thigh, a bicep or a chest. Male bodies were windows on to divine beauty, the contemplation of which was the closest most Greeks got to heaven.

Plato believed men had been placed on earth for a moral purpose. He founded his academy, the first institution for higher learning in the world, to teach men how to lead their lives. He had no time for the disinterested scientific observations of Aristotle. The heavenly ideal was all that mattered, not the broken fragments of the world below. Only men could see, in their mind's eye, the form of the good: the ideal vase, tree or man of which all actual vases, trees and men are but lowly, imperfect shadows. Plato's most famous metaphor for the human condition likened us to people who have spent their lives sitting in a cave facing a wall on which are cast, by a light above and behind them, shadows of people living and talking in the world outside. They can see the shadows move and hear them speaking, and they assume they are real people. Nature for Plato was veiled, a muted, pale reflection of the eternal, shining truth above. His ambition was to turn this veil into a doorway, and through intellectual effort, realise perfection here on earth.

Just as we had cultivated more wholesome crops, so we could breed more beautiful and intelligent youths who would create an ideal state. His programme was relentlessly top down. Man only had to look at his body for proof of the descending order of things. It was right that the head was separated from the body by a thin neck, because the soul was seated in the mind and it needed to be protected, as a harbour is by a channel, from the polluting influences

of the body below. The society Plato described in crystalline prose in *The Republic* was a version of a caste system, with handsome, golden-haired men at its head. Beneath them came the chest – the manly soldiers who would defend and police the state. The diaphragm separated these from the lower intestines, wombs and reproductive and excretory organs – the peasants, slaves and women who rightly had no say in how things were run.

Plato's hierarchy included the temporal. God must have made man first. A master of ridicule, he made fun of Anaximander for suggesting that men had developed from fish. It could only be the other way round. Fish were clearly men who had led such mindless lives that they were born again as slippery creatures which could live only in water. Men who had led lives of cowardice and injustice were reborn as women. Beasts which went on all fours clearly had once been men who'd never looked up at the stars. His greatest contempt, however, was reserved for birds, because they were descended from those 'harmless but light-witted men who paid attention to things in the universe but in their simplicity supposed that the surest evidence in these matters is that of the eye', dismissing Thales and all the observational scientists who came after him.

Christianity, a Judaic religion born in Roman times, owed much to Platonism in its early thought. It taught that the son of god, the perfect man, had been born and lived and died on earth. This prompted much speculation as to what exactly Christ's flesh and blood was. Did he have the mundane bodily functions of humans, and if so were these divine? In 325 CE the recently converted Emperor Constantine convened a council at Nicea to determine the exact nature of the body of Christ. The result was a schism in Christianity.

The Greek Orthodox Church maintained its belief that Christ had been born in the flesh of Adam before the Fall, so that his body

remained pure and undefiled. This profoundly affected how they represented the human body in their churches. Their icons are flattened images of ethereal flesh and they have remained unchanged throughout the history of their church. Still today their congregations are separated from the inner sanctum, their Holy of Holies, by a screen called the iconostasis – essentially a veil – which shows saints in serried ranks sitting in a golden heaven. According to the writings of Saint Basil, the Bishop of Cappadocia who had attended the Nicean Council, Orthodox Christians did not worship images as pagans did, but as windows on to a higher reality. There was a great deal of Platonism in Orthodox theology.

All the early Christians still lived in a veiled world, and assumed, as their early apostle St Paul said, that they could only see 'through a glass, darkly' when they were on earth, though in heaven they would see god 'face to face'. The glass that St Paul was referring to was probably a mirror, not a window, and mirrors, then made of polished metal, would have given one an unclear image of oneself. But the theology of western Christianity, alone among the great religions, as it developed, slowly and at first very nervously, began to legitimise close observation of the natural world. Monotheism and the idea of the unity of nature were closely connected, but the naturalisation of religious art was strictly forbidden in the other monotheistic faiths.

St Augustine, one of the most influential early theologians of the Roman Catholic church, was a near contemporary of St Basil's and a convert from Manichaeanism, a religion which had attempted to combine the teachings of Buddha, Zoroaster and Jesus. Augustine summed up the Roman church's attitude to the visible world and Christ's appearance in it with a generality: 'Thanks be to you, O Lord, for all that we see.' God's commandment in the Old Testament that it was forbidden to make any likeness of anything in heaven or

on earth or in the waters below the earth – an admonition upheld by Judaism and Islam – had to be overcome now that god had sent his son to walk on earth and to be seen. Western Christians believed that god had created the world within which his son had walked, and the logical conclusion of this was that the more closely one looked at nature, the more clearly one could see god.

There was, however, an additional, more pressing impetus behind the increasing naturalism in western Christian art: the urgent issue of Christ's imminent return. Earlier beliefs had seen time as cyclical. St Augustine summed up the Christian view: 'The infidel seeks to undermine our simple faith by dragging us from the straight road and compelling us to walk with him on the wheel.' For Christians time was linear, as they counted the hours until Christ's promised return. Judaism and Islam both preached that salvation would come, for the faithful, at some unspecified time in the future. But by declaring that Christ had been born in AD 1, Anno Domini, the first year of the lord, Christians had set a clock ticking. The rapid, early spread of Christianity wasn't due just to its egalitarian reach and its message of love and forgiveness, but to its messianic edge. They were preaching an urgent need to be converted, because Christ might come back at any time.

Anno Domini 1000 was a turning point for western Christianity because that was the date given for Christ's return in the Apocalypse of St John. He had seen the New Jerusalem in the night sky about to descend: it was a huge flat square, like the world below, flanked by immense, inhabited tower blocks. But 1 January 1000 dawned as usual and life went on as before. The church buckled down for what they realised could be a long wait. They began to build churches of stone, rather than wood, and beefed up their propaganda. They had to make the idea of Christ's first appearance on earth as realistic as possible, to discourage their congregations from

losing heart and beginning to doubt whether he had ever been on earth at all. Christ had appeared at a specific date in history, when the Romans were in charge. To bring Jesus back to life among the people who surrounded him, sculptors and painters turned for inspirations to the originals they could see on ancient pagan gateways, sarcophagi and coins, which could still be found in many parts of Italy and France. The artists and architects of the Romanesque had one overriding ambition: to make the age when Christ had first appeared come vividly alive.

The period from 1000 to the next millennial watershed in 1500 CE witnessed a dramatic transformation in western Christian art which developed into a period later called the Renaissance. This has been celebrated as the revival of humanism, the end of the Dark Ages and the beginning of modern times. It was, in fact, the crowning glory of western Christianity. The classical borrowings that became such a feature of the art of this period were an attempt to make Christ's appearance more authentic and did not indicate an emerging atheism. The increasing naturalism was an expression of their belief that god had created the world as it appeared. The glorious windows opened by Gothic and Renaissance artists were lit by the radiance of god's creation.

Standing in the Basilica of St Denis, the first Gothic building, looking towards the transept, is like seeing a flower unfurling in stone and glass. The clerestory was a survival into medieval times of the spirit level above our heads. In St Denis, this was transformed into a surrounding high arcade of rose and lancet windows held aloft by ribs and wreathing branches that appear to be alive and growing, not carved in stone. The walls of Gothic cathedrals melted into windows, illuminated with the sacred stories in the Bible painted in vivid detail and jewelled colours as if they were happening at that moment in heaven, while the faithful prayed in the dark below.

Altarpieces opened like windows. One of the largest is in the cathedral in Ghent: *The Adoration of the Mystic Lamb* painted by Hugo and Jan van Eyck. The light within in it is so clear that the surface of the painting disappears. Roses on briars and lilies among blades of grass are rendered with such intensity it is as if they were growing in a sunlit rockpool in which everything is bathed in liquid crystal. This supreme illusionism, unequalled in world art, was an act of praise. The precision of observation that the northern Renaissance masters brought to their work was not objective or dispassionate but a revelation, a profound expression of their faith.

Walking into the Scrovegni Chapel in Padua is like entering a bath of blue. The radiance of heaven arches over the vault and pours down the walls. The cavernous space does not seem to be windowless, for Giotto has painted daylight inside. Each scene of the life of the Virgin Mary and of Christ is like a window punched through the wall, as if these sacred events were just happening in the street outside. The faith asserted here is that Jesus has lived in our world and continues to live with us, walking beside us in our ordinary day. This is the down-to-earth generosity that suffuses Giotto's art, the intense humanity that glows out of his faces, the love expressed in his direct, dark eyes. In the Brancacci Chapel in Florence, painted 120 years later, the windows are still in rows, but they've opened wider. Everything decorative, superficial and transient has been peeled away; the air has cleared and something essential and lasting has been revealed – not an ideal, though the figures are dressed in classical clothes, but a lasting reality. In Masaccio's art we stand shoulder to shoulder on shared ground with a god who casts shadows.

The achievements of the Renaissance are often attributed to a growing awareness of the scientific discoveries of the Ancient Greeks. But knowledge of these was extremely limited, for the few

Roman translations that existed of ancient Greek philosophical texts were mainly kept on the back shelves of libraries carefully guarded by Greek Orthodox and, later, Islamic priests. A revolutionary book on optics by the great twelfth-century Islamic scholar Ibn al-Haytham was available in Europe through a translation into Latin, but he had only been allowed to study this subject because Muslims believed sight was lowly and flawed, for no one could see god. Roger Bacon, nicknamed Doctor Mirabilis on account of his intellectual brilliance, was eventually allowed to study Aristotle but only after being granted a special dispensation to do so from the Pope. The Church kept a tight grip on all knowledge throughout this period. Nature was a window which opened on to god.

Renaissance painting was, above all, an attempt to see god more clearly. But it was also, in part, a response to one single, disturbing fact that began to emerge from ancient texts: that the earth might not be flat but could, quite possibly, be a sphere. The Greek Orthodox scholar Maximus Planudes rediscovered Ptolemy's *Geographia*, which was based on this presumption, in the late thirteenth century. Giotto could well have known about this book through Venetian trade links with Constantinople. His merchant friends, ambitious to expand their trade, would have been fascinated by Ptolemy's maps, which drew the world as round and extended it as far as China. An appreciation that the world was a sphere could well have accounted for the revolutionary rotundity of Giotto's figures and, a century later, for Masaccio's even broader grasp of three dimensions. The history of Renaissance art needs to be rewritten, not in terms of the rediscovery of pictorial space or of a growing awareness of humanism and scientific thought, but in relation to the more urgent, simpler, breaking news that the world was not flat but a globe.

The elite who governed church and state in western Europe were beginning to accept that the world was spherical, though the

vast majority of the populace remained in ignorance. When Columbus had difficulty raising funds for his attempt to sail west to get to the Indies that lay in the east, it was not because royal ecclesiastical advisors thought that the earth was flat, but because they were aware that the Ancients had calculated that its circumference was much greater than Columbus was claiming. He eventually found a backer in Ferdinand II of Spain, set sail in 1492 and returned the following year. The fact that his ship hadn't fallen over the edge of the world surprised the vast majority of his fellow men but this did not necessarily change their perceptions. All Columbus had proved was that the world was wider than most people had thought. Moreover, Columbus had got nowhere near the great cultures of Mexico or Peru. All he had found were impoverished, nearly naked pagans who lived in hovels and couldn't speak Spanish or Portuguese – the very sort of lowly folk you'd expect to find living in the extremities of the habitable world.

The Chinese had come to a similar conclusion nearly a century earlier. In 1404 CE, the self-styled Emperor of the Era of Perpetual Happiness (in Chinese, *Yongle*) set over two thousand scholars to gather together all the knowledge in the world and compile his monumental Yongle encyclopaedia. Vast flotillas were sent out on voyages of discovery across the seas. Between 1405 and 1433, Admiral Zheng He, a Muslim by birth, reached Indonesia, Sri Lanka, India, Arabia and Africa. The Yongle emperor's world was still flat and he and his patriarchal line stood at the centre of it. To make the point, he commissioned an impossibly tall monument to his father, a 73-metre high stone needle which was to stand on the back of a turtle in a square pavilion, symbolising the earth floating in the ocean. Its immense base can still be seen abandoned in the Yangshan quarry.

After the Yongle emperor's death all foreign ambitions were curtailed and China effectively closed its borders to the world. It

considered itself to be the centre of the world – its ancient name, Zuong Guo, means the central kingdom – and all other countries were peripheral to it. An adventurous spirit that could have changed history was throttled at birth, turning China's intellectual life into an exquisite but frozen flower arrangement, painted in ink on hanging sheets of paper as artificial and sterile as their self-reflecting, veiled world view.

A similar veil of mystery still blanketed the west. There's a popular misconception that if Leonardo da Vinci had not spent so much time painting he could have developed powered transport and even pointed the way to sending a man to the moon. What people have difficulty appreciating in our scientific age is that painting was Leonardo's highest ambition, and he almost certainly had no idea that the moon was a place that anyone could land on – though, since a third of his notebooks are lost, no one can be entirely confident about the scope of his thinking. A sketch of the moon he made in about 1512 indicates that he thought, like many, that its substance was watery and that the shadows on its surface were made by rising mists.

More surprisingly, though lenses had existed for at least three hundred years before his time, there's no evidence to suggest that Leonardo put two together to make a microscope or a telescope. He certainly had the intellectual capacity to make such instruments and there is an obscure early note, dating from about 1490, about the possibility of 'making glasses to see the moon enlarged'. But he doesn't seem to have actually done this. Nor did he make a microscope, though he was fascinated with minutiae and the inner workings of everything, and even dissected bodies with the nervous permission of the church. Leonardo assumed, with everyone else, that there was nothing to look at beyond what one could see with the naked eye. Things could be magnified, and ageing and weak

sight helped with a lens, but the idea that our sight could be extended, apart from being corrected, never occurred to anyone. What's more, we didn't think there was anything there to see. The visible world was the whole world, and it petered out all around us in nothingness. We were meant to be bathed in mystery. Leonardo focused his unrivalled eye and intellect on this veil of mist and he did so by creating an image of it.

Painting and drawing were essential to Leonardo because they helped him study nature and understand it. A drawing enabled him to show how something like the muscles in a hand worked, in ways that couldn't be described in words. But painting added another dimension. He believed that 'the painter is transformed into the likeness of the mind of god'. This wasn't arrogance, just an acceptance of the then widely held belief that god had 'painted' his creation. Leonardo's unprecedented ambition was essentially Christian: he wanted to discover and then paint the soul of the world.

Leonardo's notebooks are scattered with observations about mist and it is likely that he was aware of the Ancient Greek theory that this elusive substance, in its manifestation in cold and warm breath, was the essence of life. Technical developments in oil painting enabled him to capture the effects of mist and smoke. The technique known as *sfumato* found its supreme expression in the painting now known as the *Mona Lisa*. This picture was probably begun around 1500, the year in which many thought Christ would return. It was possibly begun as a portrait, but nothing is known of its origin and the fact that Leonardo kept it with him all his life and never sold it suggests that it wasn't a commission but held a deeper, personal significance.

Its current display in the Louvre makes it very difficult for anyone to appreciate the painting, obscured as it is by layers of

discoloured varnish that were put on centuries after Leonardo and which could and should be safely removed. Two barriers and a greenish-tinged plate of glass prevent anyone getting close to the picture, unless you can hold your own against the jostling crowds taking selfies (with their backs to the picture) and peer at it through a pair of binoculars. Then the vibrant opalescent colours can be glimpsed beneath the brown stain, the delicate soft radiance of her flesh, and the landscape receding into distant views of rivers, mountains and seas bathed in shimmering blues. The light in the painting seems to be a combination of dawn and dusk; everything appears to be made of mist and to breathe. Substance becomes insubstantial in this lady's presence.

The *Mona Lisa* was begun only a few years after Columbus set sail. The two different misty sea levels in the background evoke not just the rising tide but also a curving ocean. The *Mona Lisa* is the personification of a new world view. Her perfectly domed head is covered by an almost transparent veil. The delicate curls that cascade from her smooth brow are waterfalls, manifestations of mist condensing into life-giving rain. Her eyes gaze unflinchingly, absorbing you in her understanding. The gentle shadows that hover around the corners of her mouth and eyes create a suggestion of almost invisible mobility. The poet Dante expressed a popular perception when he wrote, 'What is a smile if not the flashing out of the soul's delight?' Leonardo has painted an expression that knows joy and grief and encompasses life and death, the smile at the heart of creation. The painting acquired its universal resonance because it presents a new image of Mother Nature manifest in a world of veils, but seen through the clear window of Leonardo's scientific examination – the most resonant and profound expression in paint of a complete world view.

The End of the Rainbow

Human life from 1500 to the present has been totally transformed by scientific discoveries in ways that would have been unimaginable to our ancestors. These developments have been viewed by many as central to our progress towards enlightenment, and have gained wide support, for no one wants to return to fifteenth-century dentistry or the unchallenged political and social hierarchies of premodern times. But they have also been accompanied by a growing spiritual darkness. This is partly because scientific discoveries have eroded the radiant world pictures of the past within which all the major religious faiths initially flourished. But it is also because science itself has revealed darkness in the world around us.

Sir Isaac Newton, one of the great architects of the Enlightenment and at the same time a devout Christian, famously wrote, shortly before he died, 'As to myself, I seem to have been only like a boy playing on the sea shore, and diverting myself in now and then finding a smoother pebble or a prettier shell than ordinary, whilst

the great ocean of truth lay all undiscovered before me.' This process of unwrapping ignorance only to find greater ignorance within has gone on. Scientists today have identified something that is more extensive than any other known substance in the universe, but they haven't been able to detect it on any instrument. They've called it 'dark matter' and some claim that they now know more than they did, but in reality they've discovered that they know a great deal less than they thought, as many scientists acknowledge. Modern human history can be expressed in terms of a running battle over light, between those who claim to be expanding enlightenment, and those who believe enlightenment can only be furthered by a greater intelligence than ours, one whom many believe is 'all-seeing'.

In 1500 Roman Catholics were on the brink of realising that the world was spherical. The informed priests who ran the church and advised kings were by then convinced that it was. When Columbus sailed west in 1492 and returned eight months later having discovered land, the most logical explanation was that the world wasn't flat, with inaccessible, distant continents and an edge that was even further away, but that it curved like a ball. By sailing west Columbus had, it was thought, discovered the eastern tip of Asia, just as he and the king and queen of Spain expected, and as the Ancient Greeks and Romans had predicted.

The fact that the earth is a sphere was instantly harnessed to the Christian cause. It was taken to be very significant that this truth had been revealed only to Christians. God had set his sun in the heavens in order to light the paths of his followers wherever they went around the world. The vast, unprecedented empires established by the tiny, seafaring nations of Europe owed their success largely to the fact that their new world view was convincing. The realisation that the world was round – and these invaders, laughably few in number, had proved this by circumnavigating it – dramati-

cally challenged the flat-earth views of the people long settled in these places, and undermined the credibility of the ancient beliefs on which their societies and governments were founded.

After the failure of the jubilee of 1500, when Christ still hadn't returned, the church needed another injection of confidence. In 1506, Pope Julius II decided to pull down the old Basilica of St Peter's in Rome and build a vastly more splendid one, suited to Christianity's world dominion. The earth no longer had corners, so everything in the new St Peter's would curve, from the spiralling columns flanking its altar to the great, oval colonnade in front, which symbolised the arms of the mother church now reaching out to encompass all her children around the globe. A new style of architecture was born which rejected all rectitude and right angles and cut curves in stone as if it were as soft as orange peel.

For Europeans at this time, the beautifully clear, rectilinear art of the previous century appeared embarrassingly old-fashioned; it was the product of ignorance, of an age when people saw the world as flat, perhaps wilfully so in the case of Piero della Francesca. Many wonderful early Renaissance frescoes were hacked away or plastered over, with what now seems barbarous insensitivity. Everything had to be round and have body like the earth. Faceted diamonds, rock crystals and transparent gems went out of fashion and the favoured jewel became the soft and bosomy pearl. Artists' colours in paintings ceased to be translucent and gem-like and turned milky and iridescent, manifest in the shot-silk folding robes and glorious flesh tints of Bronzino, Titian and El Greco.

Baroque, the word that later came to be applied to this style, derived from the Portuguese *barroco*, meaning a misshapen pearl, an analogy which not only aptly conjures up, in miniature, the luminescent architecture that typified this style but also provides a vivid visual image of our nascent new world view. The earth stood still at

the centre of the universe, a solid, heavy sphere of rock surrounded by a tremulous surface of shining lands and seas wrapped by clouds and skies, the sun and moon and circling stars. This pearly sphere had to have a bulge at the top to accommodate heaven, which human reason prevented us from thinking could surround us and therefore be in part beneath us. Christianity had to reassure its expanding congregation that god was still seated firmly on his throne in the celestial firmament above our heads, and one of the most obvious ways to illustrate this truth was to paint images of heaven on the ceilings of churches.

The cycle of frescoes painted singlehandedly by Michelangelo on the ceiling of the Sistine Chapel depicts god's new relationship with his creation. This could no longer be understood in terms of the cross, the rectilinear arrangement of ascent, descent and horizontal expansiveness. God didn't gaze calmly down from heaven, but now flew and whirled around the spherical world in a hurricane of divine inspiration. Illusionistic ceilings became increasingly elaborate, culminating, nearly two centuries later, in Andrea Pozzo's ceiling for the Church of Sant'Ignazio in Rome, where bodies tumble between twisting pillars and billowing clouds, legs kicking, arms thrashing, as they soar up with the saint into the pearly luminescence. The saint's ascension was his reward for having founded the Jesuits, a ruthlessly disciplined and intellectually rigorous mendicant order committed to spreading the message of Christianity around the world. Faith took precedence over fact. 'I will believe', he wrote, 'that the white that I see is black if the Church says it is.' The battle lines for our ownership of our new world vision were drawn between science and religion.

In 1519, Ferdinand Magellan's fleet had set sail to discover a western route to the Spice Islands. Though he himself was killed in the Philippines (during a brutal attempt to convert the islanders to Christianity), his last ship returned three years later having cir-

cumnavigated the world. There was now no vestige of a doubt that the earth was a sphere, but this cast a shadow over the truth of the Bible, which stated there was an ocean under the earth (Exodus 20:4, and elsewhere). People began to question their perceptions, even if this challenged the teaching of the church. The Polish cleric and classical scholar Nicolaus Copernicus tentatively proposed that the Ancients might have been right and that the sun, not the earth, stood at the centre of the universe, though his theory was only published in 1543 when he was on his deathbed, for fear of recriminations from the church.

Copernicus's theory might have remained just that had we not developed the telescope, an instrument that was stumbled upon by chance, not invented by design, though much design went into its improvements after the initial breakthrough in our thought. We had had lenses for centuries and used them to correct weak sight, but we had no idea that sight itself could be extended. The French philosopher and scientist René Descartes thought our blindness to this possibility had been humanity's single greatest intellectual failure. The Dutch spectacle-maker Hans Lippershey, one of the claimants to the discovery of the telescope, which he patented in 1608, is said to have got the idea from watching his children play with lenses on his workshop floor. Uninhibited childlike questioning has frequently brought about breakthroughs in man's thinking.

The early telescopes were very weak, with just three times magnification, but they were soon selling widely across Europe as children's toys. Galileo Galilei happened to see one in Venice in 1609 and, grinding the lenses himself, made a much larger version that could magnify thirty times. In December of that year, he turned his new instrument on the moon. A case could be made for arguing that this extension of our natural sphere of vision, breaking through the veil of common sense that surrounded us, could have been the single most significant step in the history of human understanding.

What Galileo saw totally changed our perception of the world. Rather than the Virgin Mary enthroned in glory, or souls being shepherded by angels on their way to heaven, or Leonardo's limpid, misty pool, he saw a solid ball of light-reflecting rock and watched, fascinated, as the shadows lengthened on its crinkly mountain ridges. He pointed his telescope all around the heavens and observed moons orbiting around the planet Jupiter. The Ancient Greeks and Copernicus had been right. Galileo's findings weren't published until 1632, but he wrote the book in Italian rather than academic Latin because he wanted to reach as many people as possible.

This was a step too far for the Roman Catholic church, which had just succeeded in persuading its followers that the earth wasn't flat but a sphere fixed in the centre of the universe. The church had little choice but to reaffirm publicly the belief that everything above the moon remained fixed. God was in heaven above, and that was all anyone needed to know. The imminent threat of torture was enough to make Galileo renounce what he was told to call his 'suspicions' and he was kept under house arrest until his death in 1642. It wasn't until 1992 that the church formally apologised for their treatment of him and officially accepted that the earth is not stationary. All governments, whether religious or secular, including democracies, are prone to lying when they think it is in the interests of their subjects and themselves to do so.

The scientific discoveries of this period of human history, which is particularly associated with what came to be called the European Enlightenment, cast shadows across all spiritual beliefs, not only those within Christianity. The Jewish philosopher Baruch Spinoza came to the conclusion that all religions were 'a tissue of meaningless mysteries'. As a result he was excommunicated from his synagogue in 1656. While the sentence was being read out – 'Let

him be accursed by day and night . . . and raze out his name from under the sky' – the lights in the synagogue were extinguished one by one, finally leaving the congregation in total darkness. This was one of the most symbolic acts of the whole Enlightenment, when it had only just begun. The aspiritual universe that science was revealing drove others to reaffirm their faith. The French mathematician Blaise Pascal wrote, 'When I survey the whole universe in its dumbness and see man left to himself with no light, incapable of knowing anything, I am moved to terror' – a terror he expressed as fear of god, a fear which drove him more firmly into the arms of the church.

This was the great age of *chiaroscuro*, a period unique in the history of world art that found its most profound expression in battles between light and dark. This darkness is prefigured in the famous self-portrait Albrecht Dürer painted in 1500 – another millennial work. He depicted himself staring out of the painting, full-faced with a high forehead, youthful physique and perfect symmetry of features and hair. Many subsequent commentators thought that Dürer had depicted himself as the risen Christ, and thereby put his creativity on a par with god's. In fact, this self-portrait is a profound, troubled enquiry into the nature of the human soul. Like every Christian, Dürer believed that god had made man in his own image and he was, with due humility, celebrating the AD 1500 jubilee with a pious attempt to see the divinity within himself. The surprising thing is that the painting is so dark. There is blackness in its heart, in the pupils of Dürer's eyes, and darkness all around. Doubt has entered our vision of the universe. God's all-embracing light has left the world. Twenty years later, Dürer saw some of the Aztec treasures sent back to Europe by Cortés and wrote that they were much more beautiful to him than any miracle. The earth held greater wonders than the stories in the Bible, and these new wonders raised more questions than they answered.

The master of *chiaroscuro* was Caravaggio, a tortured personality drawn to lowlife, brawls and boys, who painted large, crepuscular tableaux of the life of Christ lit by divine beams shining down on furrowed brows. A painting dating from 1601 shows Doubting Thomas poking his finger into and lifting the flesh of a harrowingly realistic wound in Christ's side. Seeing wasn't enough: Thomas needed hard evidence before he could believe. The Dutch artist Rembrandt painted and drew over a hundred self-portraits, searching, as Dürer had done, for the god in himself, and in everyone. What he found was darkness. As he peered into the eyes set deep in his ageing, unlovely, bulbous face, he seemed to be asking if he really was a likeness of divinity and, if not, who was he? The greatness of his humane art lies in the frankness and openness of his exploration of the question.

Hamlet, written in or about 1600 (another centennial masterpiece), similarly asks a deceptively simple question. It is the tragedy of a man torn between the old, hierarchical order of his ghostly father who upheld clan loyalty, divine right and the natural justice of revenge and the new, more troubling, shifting order of a circular world that spoke of individual responsibility in a sea of uncertainty. 'There is nothing either good or bad, but thinking makes it so.' Hamlet is tragically caught between two world views. 'To be or not to be: that is the question' is a darker equivalent in verse, a century later, of the enigmatic smile of Mona Lisa, which hovers between an awareness of life and death. William Shakespeare, on the cusp between a god-made and a godless world, explored human nature in a glorious outpouring of well over thirty plays which were performed on a raised square platform with pillars at the corners supporting a canopy of stars, embraced by a circular auditorium, in a theatre called the Globe.

One of the most disturbing revelations of the Enlightenment was that light itself was dark. The Book of Genesis had expressed

what was still the common-sense view when it stated that god created light on the first day, and the sun three days later. But if light was a thing, why couldn't we see it en route between the source and the illuminated subject? Descartes wrote in *La Dioptique* (1637) that he thought light was 'a movement, very rapid and lively, which passes towards our eyes through the medium of the air, and other transparent bodies, in the same manner that the movement or resistance of the bodies that a blind man encounters is transmitted to his hand through the medium of his stick.' Descartes still asserted that sight was 'the noblest of the senses' – but the real discovery of the Enlightenment was that seeing could be compared with the tactile perception of someone who was blind.

Light was a mechanical movement of waves, not a flooding out of divine understanding, still less a moral probing. Seeing wasn't an active force, as we'd thought till then, a beam we sent out from our eyes that could do good or ill, a projection of our understanding on the world. Galileo's great contemporary Johannes Kepler studied the theories of the Ancient Greeks and those of the Islamic scholar Ibn al-Haytham, and then worked out how the eye actually operates. It was like a pinhole camera (something he also developed) which received light, passively, through its lens. Nothing came out of the eye at all. These discoveries didn't diminish Kepler's faith. A devout Christian, he believed that the new universe revealed by Galileo's telescope was an image of the Trinity: the sun was God the Father, the star system was his Son and outer space was the Holy Spirit.

Theories like these were reflected in Louis XIV's claim to be the Sun King, *le Roi Soleil*. He built his palace at Versailles, a vast assembly of halls, covered walkways and gardens spreading far and wide to the four directions, the last great sun temple on earth, this time a Christian one. The mirrored rooms within Versailles reflected aristocrats strolling past woven wall hangings showing happy peasants sporting in a sun-drenched countryside which their real-life

masters, also painted and powdered, fondly imagined would last forever. But the reality was that our new perception of a spinning universe was undermining all established hierarchies. Velázquez, in *Las Meninas*, painted himself painting the king and queen of Spain in a huge mirror, with their young family looking on. Facing it, you realise that the artist and the children in the painting are looking at you. It was an extraordinary conceit to put an ordinary person in the place where the king and queen would stand. But that was the changing order of the times. High and low, above and beneath, no longer made sense if we were all turning on a turning sphere.

Though a devout Christian, Isaac Newton couldn't accept the idea of the Trinity, the Father, Son and Holy Spirit. He was a mathematician: three couldn't be one. His king overruled the objections of the church and gave Newton a special dispensation to continue to lecture and study. In a flight of extraordinary intellectual brilliance, Newton worked out why an apple fell down but the moon, which was obviously much larger and heavier, stayed up. The whole concept of up and down, which had been pivotal to human existence until then, evaporated overnight. The word gravity no longer contained the implication that it was a force that was dragging you down to your grave. The symbolic meaning of the visible world melted away under science's forensic searching.

This was the era of the first political revolutions. Mass uprisings had occurred in many societies before, but they are more properly thought of as revolts against punitive taxes, cries for justice and expressions of the needs of the growing multitudes of poor, not as attempts to overthrow the system. The English Peasant War of 1381 was famously put down by the personal appearance of King Richard II, who told the angry crowd, 'You will have no captain but me.' They went quietly home. But now we knew that the whole world wasn't stationary but spinning round, and that the blood in our bodies

didn't rise and fall like the tides but was circulating as well. William Harvey's discovery, published in 1628, had taken Europe by storm. Our societies had always reflected the way we thought nature was organised, outside us and in our bodies. If everything was going round, it was perfectly natural that society could be turned round too.

What is easy to forget about the Enlightenment, looking back at it from our enlightened position, is that so much of what it tried to do was hidden from sight. We now know that Voltaire was one of the great intellects of that age (and indeed of any age), so we have to remind ourselves consciously that almost all of his satirical writings, numbering thousands, were published anonymously. His incisive, enquiring mind was the seething lava under established religious and social thought, a new world picture bubbling under an old one, which eventually erupted a decade after his death in the French Revolution. Few individuals can have changed the world so much by the sheer, relentless power of thought. What interested Voltaire was human motivation. His masterpiece *Candide* (1759) follows the fortunes of the innocent youth Candide and his tutor, the philosopher Pangloss, who, despite countless gruesome disasters, described in lurid detail, convinces him again and again that all is for the best in the best of all possible worlds. Throughout this hilarious, vicious romp, Voltaire points his ironic, bony finger at the key question facing any beneficent faith: why did a god of goodness create evil? Weren't evil and good merely aspects of the natural motivations of mankind?

Thomas Paine, in his pamphlet *Common Sense* (1776), stated what was becoming obvious, that all men were equal and jointly shared humanity's destiny. In *The Rights of Man* (1791) he argued that human rights originated from nature, and were not privileges handed down by rulers or governments that could justly be revoked.

A changing world view inspired the English Civil War and the French Revolution, during which kings' heads rolled, and the American War of Independence, which established an egalitarian society based on people's right to life, liberty and the pursuit of happiness – the last a telling shift from heavenly bliss to Epicurian contentment here below.

One of the world's earliest feminist pioneers, Mary Wollstonecraft, capped Tom Paine's *The Rights of Man* a year later with her *A Vindication of the Rights of Women*. It was a statement only, for Wollstonecraft had to contend not just with men's views of women but women's views of themselves. Women believed they'd been created ignorant by god, and were therefore unquestioning. It was still a man's world; it took an unconscionably long time for women to enjoy any recognition or independent status, let alone a vestige of equality. They eventually got voting rights in America in 1918, but in France, where the ideal of universal suffrage (for men) had first been applied in 1792, women, unbelievably, had to wait until 1946 to be given the right to vote.

Men still thought of women as lower beings, closer to nature than themselves. The most exquisite expression of our new vision of women's place in a rotating world is Jan Vermeer's *Girl with a Pearl Earring*. The young girl has turned round to glance at us over her shoulder, as the world now turned. Her eyes embrace us with their love, the pure arcs of their whites like rising moons. She is still our ancient spiritual and earthly lover, at once virginal and sexual, for light catches the wet corner of her parted lips. Had the green glaze that originally covered the dark background survived, the meaning of this image would have been more immediate and resonant, for it would be seen to represent the verdant world turning to embrace us with its love – a Mother Nature for the modern age. *Girl with a Pearl Earring* isn't an image of spiritual doubt but an assertion of an

earthly truth. The fullness of her gown suggests that she might be pregnant. But her beauty is no longer static like that of Mona Lisa, who remains monumental for all her mistiness. Vermeer's young woman has a lively, animated grace that pivots round the gleaming pearl in the shadow of her neck.

Our view of the earth, of Mother Nature herself, was about to be undermined by the Industrial Revolution. Turning wheels were crucial to the radical new forms of manufacture. Watt and Boulton patented their 'Sun and Planet Gear' in 1781. Science began to discover new sources of power within the earth itself: steam and coal, gas and, most magical of all, electricity. People in droves began to leave the countryside, where seasonal rounds were now perceived to be not so much a grinding chore as an unnecessary bore. The young in particular were attracted to the bright lights in the cities where they could work in factories through the night to earn the coins – big brown copper earths, little silver moons and golden suns – that clinked in their pockets. Money had, till then, been a finite entity, a sea level running through society, the depth of your supply depending on your social elevation, to be shared with your brother and never bartered. The laws against usury, making money by lending money, were almost universal across all human societies. But soon it was money that made the world go round.

Whole new worlds were being opened up at the ends of the new optical magnifiers. Robert Hooke peered down his microscope and saw monsters living in drops of water. His magnificent volume of illustrations, *Micrographia*, published in 1665, which included enlargements of a flea and the eye of a fly, changed people's perception of creation, and raised the troubling question of why god had made wonders too small to see. Hooke answered them by arguing that god had intended us to see them all along. Human sight had universally weakened, he wrote, when Eve and Adam sinned. Micro-

scopes enabled us to see god's creation as we had done before we'd been expelled from the Garden of Eden. Most scientific discoveries involved such sidestepping dances with the church, as a new world picture elbowed out the old.

Nothing was as it appeared. A porpoise might resemble a fish, but when Edward Tyson dissected one in 1680 he found it was more like a squashed-up dog inside. Carolus Linnaeus set himself the task of completing Adam's work by naming all the species on earth. It had been assumed that species – a word derived from the Latin *specere*, to look at – were living things that looked alike. But Linnaeus soon realised that species could not be defined by their appearance but by whether or not they bred true. Sex reared its head. Flowers which for millennia had been images of spiritual purity – the lotus blossom on which the Buddha meditated, the tulip that was the flame of religious aspiration in Islam and the rose that personified the Virgin Mary in Christianity – were now revealed to be flagrant displays of vegetative sexuality.

One observable fact, however, stood firm: each species was eternally distinct, and had been set on earth by god. Linnaeus, a devout Christian, was convinced that a Tree of Life still grew in the heart of creation. And on top sat man, the closest link in the Great Chain of Being to god. In 1735 Linnaeus classified four distinct species of *Homo sapiens*: 'American: hair black, straight, thick; nostrils wide, face harsh; beard scanty; obstinate. Paints himself with fine red lines. Governed by custom. European: hair yellow, brown, flowing; eyes blue; gentle, acute, inventive. Covered with close garments. Governed by laws. Asiatic: hair black; eyes dark; severe, haughty, covetous. Covered with loose garments. Governed by opinions. African: hair black, frizzled; skin silky; nose flat; lips tumid; crafty, indolent, negligent. Anoints himself with grease. Governed by caprice.' In the minds of Christian Europeans, this hierarchy of

humanity justified the slave trade, by which they shipped millions of Africans across the Atlantic in appalling conditions to live short lives on their cotton and sugar cane plantations.

Time got deeper and space became wider. In 1654, Archbishop Ussher, after a lifetime's study of Biblical sources, had dated the creation to 26 October 4004 BC, at precisely nine in the morning – making the Christian world a little older than the Jewish estimate of 3761 BCE. But in the next century James Hutton discovered the immense age of rocks. The world was much, much older than people had thought. William Herschel, the King's Astronomer, looking at the stars through ever bigger telescopes, discovered tiny galaxies like our own Milky Way, and realised that, because light takes time to travel, he must be seeing these galaxies as they were millions of years ago. The bewildering time scales of rocks and stars opened a new perspective on the nature of nature itself.

It was becoming clear that god had not created the world as it now appeared. In France the Comte de Buffon came up with the radical notion that nature itself had a history and he opened the door to the alarming possibility that some animals, even if created by god, might no longer exist. Work was going on apace arranging fossil bones in rows. Time opened wide its curtains: in the 1820s dragons began to walk across the stage of our past, as real dinosaurs, not fantastic monsters. Charles Darwin, after decades of painstaking research, finally solved what he called the 'mystery of mysteries' – how different species had emerged – by arguing that no offspring is exactly the same as its parents, that these and tiny differences were able to give one creature an advantage if times got hard. Those that survived were the fittest, that is the most suited to their changing environment, rather than the strongest.

Darwin's book, *On The Origin of Species by the Means of Natural Selection* (1859), is a condensed masterpiece of translucent

thought and prose. The whole panoply of life, including human beings, had evolved, he wrote, through the 'clumsy, wasteful, blundering and horribly cruel work of nature' over countless millennia. 'Our ancestor was an animal which breathed water, had a swim bladder, a great swimming tail, an imperfect skull, and was, undoubtedly, an hermaphrodite.' 'It's absurd,' he argued, 'to talk of one animal being higher than another.' 'Man, wonderful man . . . with his divine face turned towards heaven' collapsed, in his book, into nature's mindless, godless melting pot.

'Darwin's book is very important,' Karl Marx wrote, 'and serves as the basis in the natural sciences for the class struggle in history.' Revolution acquired the added dimension of evolution. Mankind could not only change society; by doing so man could change himself. Marx constructed the vision of international socialism sitting in the (intentionally round) Reading Room of the British Museum, the great institution that had been founded in 1753 to bring together the knowledge of the whole world, a modern-day Library and Museum of Alexandria. His close associate, Friedrich Engels, using curiously anachronistic hierarchical imagery, asserted that Marx, with 'his lion-like head and jet black mane', was destined to 'pull down to Earth the spacious tent of Heaven up on high'. The communist revolutions that followed, in Russia, China and around the globe, heralded the emergence of an advanced type of 'social mankind' and undertook nature's evolutionary role by re-educating or, if that failed, exterminating old forms of humanity that they regarded as reactionary.

Adolf Hitler was a failed painter who decided to become an artist of life. Darwin's 'survival of the fittest' was transformed in his ignorant mind into the Nazi banality of blue-eyed blonds with biceps, so unlike himself. His agenda was to a large extent visual. Millions of Jews and other people who didn't fit into his fantasy of

racial perfectibility, such as gypsies, people with disabilities and homosexuals, were subjected to degrading physical examinations and then murdered in cold blood. Hitler has to be understood not as a demon, nor as a madman, but as someone nurtured within the common sense of his time. He was only doing what Luther had preached, in eradicating the Jews, and what Plato had proposed, in breeding a super-race. He was insane perhaps only in his irrational determination to see this programme through to a 'final solution'.

The European Enlightenment had begun in earnest when Galileo turned his telescope on the moon in 1609, and it drew to a close with the publication of Darwin's *On The Origin of Species* 250 years later. This extraordinary era of intellectual examination witnessed the systematic demystification of everything we could see. The visible wonders of the world, the sun as king, the moon as mothering lover, the stars as souls of the dead and those waiting to be born, mountains, clouds, rivers and seas as the homes of eternal spirits, animals as ancestors and divine messengers, and man himself, the dome-headed, upright, striding image of a god – all these wondrous images of creation burst like bubbles, their colourful illusions probed by science's searching scalpels which revealed that the actual workings within them had nothing to do with how we saw them.

The new visions that the Enlightenment began to paint, of either a man-centred or an utterly inhumane, godless universe, threatened all governments, both material and spiritual, that had been based on a symbolic interpretation of the visual wonders of our daily life. All around the world, nations and faiths barricaded themselves against the corroding force of these ideas, as Roman Catholic Christianity had done within its citadel, the Vatican. China withdrew its government behind the walls of its Imperial City, which became forbidden to all outsiders. Japan literally closed its country

to foreign influences from 1635 for 250 years, until it was forced to open again to western trade in 1858, sustaining, within its hilly archipelago, a beautiful world picture founded on a magical, if brittle, amalgam of the Tree and the Veil. India remained open, partly because it was dominated by Britain, first through the trade of the East India Company and later as a colony, but more significantly because Hinduism could absorb any ideas into its multi-faceted, organic vision of a churning, ever-changing universe. Galileo, Newton and Darwin posed no threat to their beliefs. Hindus had long maintained that creation was millions of years old and perpetually transforming, and that every living thing had gone through countless reincarnations, from worms to humans and back to worms again.

Factions in Islam reacted against the advance of European science, which their own philosophers had helped to inspire, by attempting to turn back the clock. Muhammad ibn Abd-al-Wahhab advocated a return to the clear, uncomplicated faith of the first three generations of Islam, when state and religion were inseparable. The Saudi state, which he founded with Muhammad ibn Saud in the eighteenth century, suffered a chequered history until it conquered Mecca and Medina in 1802. Shia Muslims were castigated as infidels and all non-Muslims merited hatred and, if necessary, extermination. This uncompromising stand appealed wherever there was smouldering resistance to European colonial exploitation, such as in Asia and Indonesia, and above all in Africa, where the hypocritical activities of Christian slave traders drove millions into the arms of Islam. Sunni Islam provided a safe haven, the most convincing alternative to Enlightenment thinking, a step back into an earlier world-picture, when the earth had a fixed heavenly contact centre, at Mecca, when male dominion was unquestioned and women wore veils outside the home. The crescent moon rode high above the

domes of their mosques, separating the changing world below from the eternal world above, where god still sat in heaven far above the reach of western scientific thought.

The struggle between the new, emerging scientific world picture and our ancient, spiritual ones was neatly encapsulated by our changing attitude to blindness, which demonstrated why the scientific view had, to a great extent, won. Before the Enlightenment, blindness had been regarded as a punishment or a gift from god, depending on your belief. Blind people were an object of legitimate ridicule among Roman Catholic Christians; you'd clearly committed a terrible sin if god had deprived you of the ability to see. Protestant Christians, however, like Hindu Sadhus and Buddhists, regarded blindness as a divine blessing, that helped one focus on one's inner spiritual life. But everywhere blindness was believed to be an unalterable fact of fate, a condition created by god. Diderot, however, argued in his *Letter on the Blind for the Use of Those Who See* (1749) that creation as a whole was not ordained by god, that the sense of touch was just as important as that of sight, and that therefore the blind could and should be taught to read. The proposal was so radical that it was one of the issues that landed him, albeit briefly, in gaol. It was not until 1829 that Louis Braille, blind from the age of three, invented a form of writing that sightless people could read by touch. One of the Enlightenment's greatest achievements was to liberate the blind.

A cry of beauty and of loss reverberates through the arts of the eighteenth and nineteenth centuries and lingers into the twentieth. You could hear it as well as see it, for this was the great age of the orchestra, when music, now that sight had lost its eminence, came into its own and crowds sat still in halls, as they'd never done before, with their eyes shut, listening intently to sounds which they trusted came from ethereal spheres. People had listened to

Monteverdi and Bach with their eyes open, and seen the notes sparkle on the architecture of heaven. Theirs was the ceiling-painting music of the Baroque, soaring cadenzas with only shadowy whispers of doubts. The darker cadences in Mozart's later symphonies and those of the great composers who came after him – Beethoven, Brahms, Tchaikovsky, Sibelius and Mahler – echo in the chasm that was widening between god's visible creation and his receding presence. Opera, which began as a self-conscious revival of Ancient Greek musical tragedy in Florence around 1600, flowered as a vehicle for expressing personal tragedies, particularly women's, in societies in which accepted hierarchical mores, particularly men's, were being challenged. Wagner's vast output, and his vision of a *Gesamtkunstwerk* (total work of art) celebrated nothing less than the Twilight of the Gods, the long drawn-out cry of a dying world vision.

Artists looked around them at the new world that was forming, and were troubled. Goya witnessed at first hand the horror of revolutionary war. Battles before had been hierarchical, gruesome pageantry among bands of men employed by the aristocracy; now they became universal carnage, as the masses were mobilised. In *The Third of May, 1808* he painted the first and still the most powerful depiction of man's meaningless, cowardly, inhumanity to man. His harrowing etchings *The Disasters of War* were too shocking to be published during his lifetime. In his last years he became a recluse, withdrawn from the glittering Spanish court, and created the world's darkest room, hung with black paintings of his nightmares. One, *The Giant*, shows a belligerent monster towering in the night sky over a war-torn, revolving world. The monster is man.

In 1856, the Pre-Raphaelite painter John Everett Millais painted a picture of a poor blind girl unable to see a double rainbow arching over her head. A butterfly is sunning itself, unseen by her, on her tattered cloak. The Pre-Raphaelites wanted to turn the clock

back to an age before 1500, when god was visible in his creation. They had been inspired by the writings of John Ruskin, who could not believe that a peacock's feather had evolved purely to interest peahens, as Darwin maintained. He thought feathers demonstrated the harmonious balance within god's creation, for a bird's feather, he argued, is exactly halfway, in its curved, cupped, frilled, fragmented form, between the scale of a fish and the fur of a mammal. Praise unfolds in Ruskin's 32 volumes of glorious prose, describing everything from an insect's wing to high, trailing clouds, from the mosaics of St Mark's in Venice to a fern frond unfurling in a fissure of gneiss – all wonders, he believed, of god's inspiration.

The nineteenth century witnessed an efflorescence of art celebrating nature, just as scientists were stripping it of all poetic meaning. Two centuries earlier, Isaac Newton had demystified the rainbow with the discovery of the mechanics of the spectrum. He could make them appear at will through prisms. The German poet Goethe argued passionately against this materialism. Rainbows couldn't merely be tricks of the light; they had to have a spiritual dimension. In a series of scientific experiments, which he regarded as just as important as his poetry, he showed that rainbows could be created by spinning discs of light and dark. These, he believed, demonstrated the existence of a moral order in creation. When good battled with evil, as in the play of dark and light, then the beauty of god's grace was made manifest in the world.

Many artists were excited by new scientific discoveries, but still clung to an emotional, symbolic interpretation of the universe. Constable's cloudscapes, Turner's sunsets and the sunlit canvases of the Impressionists were modern in the objective freshness of their observations of light effects, but they also express these artists' love of nature. In his great rambling epic *Leaves of Grass*, Walt Whitman wrote: 'The sun and the stars that float in the open air . . . the apple-

shaped earth and we upon it . . . surely the drift of them is something grand.' Like Ruskin, he felt certain that 'a leaf of grass is no less than the journey-work of the stars'.

Van Gogh was thrilled when he first saw Japanese art, as it began to trickle out from a society that had barricaded itself for 250 years against the European Enlightenment. Here were people, he remarked, who didn't waste their time measuring the distance between the earth and the moon. Van Gogh pondered, in his literal but wonderful way: 'Why should the shining dots of the sky not be as accessible as the black dots on the maps of France? If we take a train to get to Tarascon or Rouen, we take death to reach a star.' The upward coiling black cypresses – to him the flames of death – would carry him there.

In Tolstoy's novel *Anna Karenina*, the character Levin cannot accept that 'this whole world of ours is nothing but a speck of mildew, which has grown up on a tiny planet'. He is at a loss when a priest asks him: 'What will you reply to your children when they ask you who made all the lovely things in the world – the earth, the water, the sun, the flowers and the grass – will you answer "I don't know"?' His resolution of this problem concludes the novel, after the emotional trauma of the love affair between Count Vronsky and Anna Karenina has subsided. Lying on his back in a forest glade, looking up into a cloudless sky, Levin assures himself: 'In spite of my knowing about infinite space I am incontestably right when I see a firm blue vault.' Happiness floods through him as he realises that the beautiful world he can see is a moral vision overlying the dark, amoral world revealed by science. The evanescent beauty of the world was the goodness in people's souls. It was a tenuous if noble hold on the sphere of appearances.

In 1893, Edvard Munch painted the world's last symbolic image of a sunset. Inspired by an amazing heavenly conflagration,

caused by the detritus from the eruption of the Indonesian volcano Krakatoa on 27 August 1883, Munch wrote: 'One evening I was walking along a path . . . the sun was setting and the clouds turning blood red. I sensed a scream passing through nature . . . I painted the clouds as actual blood.' The divine robes that nature had been dressed in for millennia, all those deep emotions generated by the sight of the sun, were finally torn asunder. *The Scream* rapidly became famous because it voiced a universal feeling. We were all utterly alone, our eyes and mouth wide with fear, our hands clasped to our face, listening to a hollow wail as the veil of beauty was torn from the world.

Glimpses of Enchantment

The darkness of the universe deepened during the twentieth century. At first we had believed that light somehow existed in the air all around us. The Bible taught that the first command of god was 'Let there be light.' He didn't create the sun, moon and stars until the fourth day. They were late arrivals in this bath of divine illumination. Light was goodness battling everywhere with the blackness of evil. Now we had come to realise that light was a rare commodity in the universe and that it travelled towards us in waves, mechanically, from our nearest star, the sun. We lived surrounded by darkness. But this darkness wasn't the velvet cloak of the devil, it was far darker than that: it was the annihilating blankness of utter indifference.

Once we thought that there was light within us. Rays of light shone out of our eyes which could heal or harm according to the condition of our souls. Now we knew that our eyes were merely vacant cups waiting to be filled; nothing physical came out of them

at all, still less were they agents of good and evil. We'd discovered that there was darkness within us, and this too was a blankness of inner indifference. Darkness flooded through outer space and inner space, and this all-pervasive darkness began to seep into our thoughts and hearts and penetrate what was left of our souls.

We came to realise that nature wasn't a veil shielding us from the unbearable radiance of a good god, but a shroud screening the universe's dark indifference to our fate. The sky and bright clouds were skims on the curved atmosphere that separated us from the vast emptiness of space; the stars, sun and moon weren't shining souls but pinpricks in the immensity of the cosmic night. And everything we could see close to us, flowers and the faces of people we loved, glistening beads of dew or the vast expanse of sparkling seas, no matter how brightly they glowed, were merely the thinnest films on the surface of the unfathomable, lightless, atomic spaces within.

We ceased to be certain exactly where we were – with doubts we hadn't had before – not only in space but also in time. Marcel Proust spent his early years reading and translating Ruskin, the great eulogist of natural beauty, but then devoted himself to examining our place in time. This is as real to us as the position we occupy in space, which we can measure with our eyes but it is, in fact, extremely difficult to locate, because we experience the present only fleetingly and sporadically between our drifting memories and daydreams. Towards the end of his vast novel, *À la recherche du temps perdu*, the narrator describes how 'a feeling of vertigo seized me as I looked down on the vast dimension of time that was my life, that was in fact me.'

In the contemporaneous novel *Ulysses*, James Joyce exploded one day in the life of Leopold Bloom into an immense kaleidoscope of glittering, frequently hilarious, imaginative phrases. Towards the day's end, Bloom gazes up at 'the heaventree of stars' and contem-

plates the 'immeasurably remote eons to infinitely remote futures in comparison with which the years, three score and ten, of allotted human life formed a parenthesis of infinitesimal brevity,' as he pees into the darkness, marking, as he does, his place in the universe. The whole compass of modern man's bewilderment and inescapable reality is contained within this vast novel. Samuel Beckett, Joyce's close associate, turned round the feelings of negation that he had been doing his best to suppress and let them flower in his black comedy, *Waiting for Godot*. In an unlikely play that caught the world's imagination, two tramps, under a nearly lifeless tree, discuss, in a manner of speaking, the absurdity of living.

The century had begun with an explosion of scientific and artistic thought. At the same time that Einstein, Rutherford and Bohr were proposing models for the structures of universes beyond human sight, in both the macrocosm and microcosm, the painters Picasso and Braque shattered art's dependence on appearances by hacking into conventional space and time, using only black, white, greys and the occasional muddy brown. The rainbow of representation had faded from the world. The artists' friend, Henri Matisse, objected. He felt that they'd reduced life to little cubes, hence the Cubist movement's derogatory name. Matisse believed that the all-encompassing embrace of space could be understood in terms of seas of radiant colour. The glorious deep red in his *Red Studio* (1911) floods through the floor, walls and furniture. Only the framed paintings in it are filled with rainbow hues, but these are even more insubstantial than the glowing red space around them: they're windows on to other worlds, suspended like luminous clouds in the artist's imagination. Our own inspired consciousness enabled us to glimpse oceans of enchantment within the encroaching darkness.

In 1910 Kandinsky happened to see one of his landscapes accidentally propped upside down. It was incomprehensible as a

representation but surprised him with its 'glowing inner radiance'. This made sense: the world was a sphere and could be viewed from any angle. He began to paint abstract works, freeing artists in the future to create purely imaginative pictures rather than earth-bound representations – art for the Space Age. He believed every line and colour had its own spiritual source. 'The deeper the blue,' he wrote, 'the more it draws one into infinity, awakens in one the longing for the pure and, finally, for the supernatural.' Kandinsky thought that art resembled religion because 'the development of art does not consist of new discoveries which supersede old truths and dismiss them as aberrations (as is apparently the case with science). Its development lies in sudden revelations like flashes of lightning . . . that throw a brilliant light upon new perspectives and truths which are basically no more than organic developments of earlier wisdom . . . Would the New Testament have been possible without the Old?'

The other great revolutionary abstract artist of the early twentieth century, Piet Mondrian, also eschewed representation in search of spiritual truth. He was a follower of the Russian-born Helena Blavatsky, whose ambition was to discover the ineffable source of all world religions. As a Buddhist monk contemplates a blue flower, then thinks of the blueness only in his attempt to reach a higher state of mind, so Madame Blavatsky compared 'the living devotion to Christ in the mind of the Christian' to 'a beam of blue light that shot upwards towards the sky'. Mondrian reduced his imagery to horizontal and vertical black lines of force in white space which, at their crossing points, occasionally generate intense bursts of primary colours – a modern manifestation of Goethe's theory of the rainbow as a product of moral conflict. Mondrian's grid was essentially an expression of our common sense of breadth and verticality, radiance and gravity, as interpreted spiritually by Madame Blavatsky. He imprisoned the new darkness in the world within a

disciplined inner vision. When Mondrian visited the abstract painter Ben Nicholson in Britain and saw a window in his studio, he said, 'Too much nature for me.'

Sunlight cast shadows, and this gave the modern age its most effective form of communication and greatest artistic expression: photography and film. All appearances had become deceptions, but the mechanical forms of representation were acceptable, partly because they were wafer-thin. The whole panoply of twentieth-century history is on film. People sat watching flickering shadows in darkened rooms, like Plato's subjects in a cave, and these insubstantial images provided most of us with our main grasp of the new global reality beyond the limited compass of our lives. Nevertheless, everyone was still living in a three-dimensional world that they could see and feel, and a few artists went on doggedly depicting this reality, though their work was dismissed as reactionary by those who thought that art had to be abstract to be modern and 'progress' in some way.

Edward Hopper's *Nighthawks* (1941) was and still is one of the most popular and profound paintings of the twentieth century. It catches that moment in a New York diner late at night when the few occupants fall silent, lost in their own thoughts, expressing the isolation we all feel in the vast cities we have made. It was an imaginative composition, yet it looks like the rendition of an actual scene, a still from a film. The key to its poetic power is the glass. The four individuals in the diner are seen as if in an aquarium, ringed by windows. This cuts them off from the emptiness of the world outside. Behind the figures is another window that barricades these isolated souls against the encroaching dark. *Nighthawks* captures the invisible barriers between every one of us and between the world illumined by our consciousness and the darkness of the unknown universe beyond.

Glass became a symbol of our modern perception of reality, a *de rigueur* feature of modern building. At the start of the twentieth century, walls were rectilinear and white. We wanted to face the future with a clean sheet. Building units which were efficient and egalitarian and lacked individual, decorative flourishes could be mass-produced. Moreover, their right angles and proportions expressed in a new way the reassuring classical values of balance and harmony. This architecture took its inspiration from modern abstract painting, above all from the work of Piet Mondrian, whose black and white grids could be erected on the ground. In comparison with Kandinsky, he was still living on a flat earth.

Though we all now knew that the world was spherical, our buildings at first remained stubbornly rectangular. But soon modern architecture began to open up. To visit the wonderful little Schröder House (1924) in Utrecht, built by Gerrit Rietveld for the woman he loved and her children, with its sliding walls, pivoting sills and sheets of glass, is to experience modern white partitions and Japanese screens unfolding like a flower into a contemporary, encompassing, translucent vision of the universe.

Translucency transformed the twentieth century. White turned into light. Walls disappeared in open-plan offices and homes, and transparency became the guiding principle for the conduct of all public affairs. Workings had to be seen and motives exposed. Richard Rogers and Renzo Piano attracted world attention with their Pompidou Centre (1977) by hanging the building's service guts and ducts on the outside of a huge glass case, leaving the space inside open for any use (which was problematic for pictures that had been painted to be hung on walls), but they were still thinking inside a box.

The arching shells of the Sydney Opera House (1957–73) caught the popular imagination because they suggested a spherical

rather than a rectangular view. Its segments are sliced from a globe. Jørn Utzon demonstrated on film how he had designed them by cutting up an orange. They are white, not transparent, for this building saw itself as standing at the beginning of modern architecture. It is the way these segments imply a sphere, more than the incidental references they make to sails and waves, that struck a chord around the world and made people feel that this building was not only new but an icon for its times. Utzon was intrigued by the vast raised altars of the past, and built his Opera House on top of one, in the belief that the arts were the sole legitimate occupants of the spirit level in our modern age.

Buckminster Fuller's geodesic domes (developed, if not invented, by him in 1948/9) were, however, transparent, and they caught the popular imagination as images of the future, though they didn't find much use except as diminutive greenhouses in eco-friendly gardens. The problem was that people didn't actually want to live in them, any more than they wanted to drive around in bubble cars. Doors don't fit any better into domes than they did into pyramids. The reason was simple: world views are all-embracing entities, and have no need for entrances or exits. Geodesic domes proved ideal as modernist containers for displays at world fairs – most famously at Montreal's Expo 67, where the shell of one still stands – and to house the Spaceship Earth exhibit in Disney's Epcot Park (1982).

Fuller's 'dymaxion' principle of using lines of tension to create strength did, however, prove very effective in spanning rivers, aerodromes, factories and shopping malls. Visionary architecture, employing this engineering, flowered most beautifully in places of departure and arrival. The bridges of Santiago Calatrava and the airport terminals of Norman Foster are expressions of modern dynamism, a world that wants to be going places, gleaming images

of the technological advance first promised by the European Enlightenment, mankind reaching for the stars.

Stars became symbols of hope for the future in the modern, scientific age. Napoleon wore a white star on his breast, the badge of the Légion d'honneur, which he invented in 1802 after the Revolutionary Committee had abolished all the chivalric orders in France. Stars graced the flag of the new republic of America and, later, those of the communist states of Russia and China. Even women were allowed to become stars, especially blondes, as they began to emerge from under the dominion of men, though at a safe distance behind the silver screen. In 1962, Marilyn Monroe sang 'Happy Birthday' to President John F. Kennedy, sewn into a body-hugging dress, a moving milky way of a myriad artificial diamonds.

During the Cold War between America and Russia, the Space Race was played out as a joust between cosmic engineers. It culminated in the moon landing on 20 July 1969, the achievement of an ambition which was the nearest thing in modern times to pyramid building, in that the vast effort involved had no practical purpose; it was purely symbolic of our belief that science could solve all our problems – man stepping on to the stars, the promise of the Enlightenment. Some have suggested that this programme ended not in the peak of attainment but in a platform invisible from the ground, like the Great Pyramid at Giza, and was a classical military deception during America's war with Russia, no more elaborate than Operation Fortitude which deceived Hitler about the Allied landings. But these lone voices have been ridiculed in the same way as all those that have questioned the accepted world pictures of the past.

The Space Race did, however, have one unlooked-for side effect. On Christmas Eve 1968, the Apollo 8 astronaut William A. Anders took what has become the world's most famous photograph.

It showed, in full colour, *Earthrise* as seen from the moon. We had done what we had always wanted to do: seen ourselves as others see us. The image seeped instantly into our collective consciousness, as if we'd hungered for it: the sight of our exquisite sapphire and emerald, cloud-coiled sphere, spinning in the vast emptiness of space. *Earthrise*, however, also made us realise just how fragile our world was. The atmosphere we depended on was a thin, swirling, rainbow film separating the earth's inhabitable surface from the hostility of outer space. Our belief that the world would look after us – an assumption that had sustained us for millennia – suddenly evaporated; we realised that we had to look after our planet. We began, at last, to take a global view and think holistically.

Holism, the brainchild of General the Right Honourable Jan Christiaan Smuts (*Holism and Evolution*, 1926), first took root in the west coast states of America as holistic medicine, treating the whole individual, not just the disease. Then it became the credence behind New Age thinking, itself a reaction against the atom bomb, the holocaust, the genocides of communism and the threat of pollution. Established politics, religions and commerce had failed to bring peace to the world. This was the dawning of the Age of Aquarius. Hair flowed long, in the manner of the Sadhus. Shamanism, Hinduism and Buddhism were acceptable, especially the Tantric cult that encouraged sex (the contraceptive pill had just became widely available) and mind-enhancing drugs. A psychedelic ejaculation of pinks, oranges and lurid greens swirled around the globe in the spaced-out minds of the fellow travellers on Planet Earth. All you needed was love, and the problems of the world would dissolve into a rainbow of harmony that would unite the whole human family in everlasting peace.

Then the Gaia Theory appeared – a scientific answer to all New Age dreams. It was the brainchild of the British scientist Dr

James Lovelock, who had earned a considerable reputation detecting polluting chemicals in the atmosphere. During the 1970s he developed his own holistic theory that organic and inorganic matter were part of one intricate, interconnecting system. He hypothesised that living organisms, even those as small as algae, helped to regulate the atmosphere of the Earth. His neighbour in the pretty English village where he lived, the novelist William Golding, suggested a name for his theory: 'Gaia', after the Ancient Greek earth mother goddess. The theory enjoyed global success because it suggested that the earth would not only care for us but care for itself if we allowed it to. Scientists such as Stephen J. Gould and Richard Dawkins led the attack – the link between inorganic and organic matter was still unexplained and there was no way that an atom, let alone the whole earth, could be thought of as a sentient being. But their criticisms fell largely on deaf ears, because our first world picture of Mother Nature, the ample-bosomed Venus of Willendorf, still lurked fondly in our thoughts.

Shadows of old world views beset our thinking today. Many businesses are still founded on flat-earth thinking and judge the success of their operations by measuring profits above a bottom line, not by assessing the total impact of their company on a community, in the round. The journalist Thomas L. Friedman argues in *The World is Flat* (2005) that globalisation makes the world of commerce a level playing field, for developing countries will soon be able to compete equally with the richest nations. Bizarrely, financiers still go on erecting needles, those condensed pyramid cores invented in the era of Hatshepsut when our world really was flat and had a centre where the pharaoh walked. Chicago and then New York built the world's first skyscrapers, many constructed by Native Americans who, strangely, had no fear of heights. The Chrysler building (1928–30), designed by William Van Alen, is a modern totem pole in stain-

less steel, sprouting eagles and topped with seven tiers of radiating rising suns, celebrating the apotheosis of the motor car.

With hindsight, it wasn't surprising that the twin towers of the World Trade Centre were on al-Qaeda's hit list; they were masking their ghastly aggression under the guise of a conflict between two world pictures. Traditionalists, not just in Islam but within Christianity and Buddhism, as well as whole countries such as China and Japan, had, for centuries, resisted the erosion of their world pictures by the materialism of the European Enlightenment, particularly its unrestrained financial systems. In orthodox Islam, no earthly building is allowed to overtop a mosque. A similar veto, applied to Christian buildings, was applied in seventeenth-century London – when fifty-two exquisite marble spires and St Paul's great dome, all designed by Sir Christopher Wren after the great fire of 1666, reigned supreme, penetrating a pure, white spirit level above the earth-bound, materialist tide of London brick.

The image of the tree continues to haunt our imaginations. The notion of tracing a single line of inheritance back through first-born sons is a sexist fantasy, yet family trees are still painstakingly researched and drawn, many of them emblazoned on parchment – the sheets of stretched, dried animal skins which we used before we invented paper – to give these documents the authority of antiquity. In reality the influences that make us who we are spread backwards rapidly in all directions from both our parents' multiple antecedents. We're all low scraggy bushes in a tangled shrubbery, not tall, straight trees towering above the jungle. But inheritance is still dominant in families, business and in politics. Had George W. Bush not been the son of President George H. W. Bush, then the 2000 cliff-hanger American presidential election might have swung more convincingly in Al Gore's favour, and the world could have been led by a president committed to an ecological agenda rather than one who believed technology would solve all our problems.

Altars and veils still hang about in our perceptions. A ceiling, now glass, still prevents women rising to power in many walks of life. The upper and lower classes are now virtually identical in appearance, and bosses walk into elevators indistinguishable from their workers. The Enlightenment started an irreversible change in what we wore. All that elegance of the past, cock-pheasant displays and elegant dresses, Sunday best and servants' clothes, soldiers' uniforms and defining garb for every trade, each item immaculately stitched and laundered, precise statements of our rank and class, disappeared like Cinderella's gown at midnight, and everything became standardised, as we were underneath. The suit appeared, boiler or tailored, with a white collar for clean, desk jobs and a blue collar for dirty, sweaty ones, because a spirit level still divided those who worked with their heads from those who laboured with their hands. Shell suits became everyday wear for anyone, man or woman. Now conformity is disappearing as individuality rears its head, and people from all walks of life are partying in outlandish gear, as if there were no tomorrow. The excessive care we now take over minor health and safety issues disguises the fact that we can't cope with the big threats we face.

Social divisions remain but they are becoming increasingly invisible. Celebrities today do their best to be the same as everyone else, as trumpeting an outstanding quality disqualifies someone from becoming one. The famous have to be as normal as they can. The only difference between them and you is that they, not you, are on the other side of the pixel screen where they exist in cyberspace, heavenly beings sitting beside you in your living room. Big Brother, the monster face of the state peering into people's private lives, imagined by George Orwell in his nightmare vision of a communist dictatorship, *Nineteen Eighty-Four* (1948), has flipped roles and turned into a selfie. Now the people, en masse, are peeping toms looking into the lives of a few individuals, just like themselves, who

have been incarcerated in a room with nothing to do – a human zoo. It has a certain morbid fascination, watching the human species fiddling while its world disintegrates, but it's disheartening to think that, for many, this appears to be the only reality they want to know.

The tragedy for mankind is that no sooner had it fully dawned on us that we were living within a spherical atmosphere than Planet Earth turned into a fragile bubble before our eyes. And a bubble when it bursts disintegrates into an ugly mess, like the spent shreds of a popped balloon. The Guggenheim Museum in Bilbao, designed by Frank Gehry, created a sensation when it opened in 1997 because it looked like a balloon caught in the moment just after bursting, modelled in 3D and electroplated in titanium – another cathedral to the arts, but dramatically different in feeling from the positive triumphalism of the Sydney Opera House built less than half a century before. The world is now littered with what David Kemp, the British sculptor of New Tribalism, first dubbed 'crashed spaceships', self-proclaiming iconic buildings aimed at putting cities on the map, which are in fact fractured images of the world's disintegration.

Thirty-five thousand years ago, when we had an enchanting vision of the world as our all-providing, fecund, living mother, there were possibly about five million of us around the globe. Now there are seven billion, and our numbers are increasing. Until the 1960s we'd assumed that Mother Nature would provide for us. The sea teemed with fish, especially after the Second World War during which fishing had effectively ceased, allowing wild stocks to burgeon. But even by the 1960s, two-thirds of the world's population was undernourished. Humanity began to see itself as a disease on the face of the earth. The very word growth – once so full of hope – now makes us think instantly of cancer. And cells, those breathing,

wondrous building blocks of life, first seen and named by Robert Hooke in 1665, now conjure up in our minds images of prisons or hidden gangs of terrorists.

We abuse the planet not just because of our immense numbers but because our vision of it is so disenchanted. We're sitting back and watching, with apparent helplessness, our world's end, beginning in slow motion. Most of the major estuaries, where our species first blossomed, are now 'dead zones' where vast algae blooms, fed on waste nutrients, rob the water of oxygen, killing all other life beneath. Immense 'garbage patches' lie in quieter stretches between the great ocean currents, each clogged with billions of fragments of non-degradable plastics that are killing fish, birds and larger creatures such as turtles, dolphins and whales. No reach of sea water is now unpolluted and the numbers of krill and plankton, at the bottom of the food chain, are declining at a catastrophic rate. Vast holes are appearing in the upper atmosphere, the largest recorded over Antarctica in 2006, thinning the ozone layers that cushion us from cosmic radiation. We are gouging into the rain forests while deserts eat into once-fertile land, and the deep fresh-water aquifers of the world are being drained. A mass extinction of species is under way, the first ever triggered by one kind.

The tsunami of 2004 struck a deep chord in the human psyche. Sea level, which had for millennia provided a measure for our existence, was no longer a fixture. And, even more alarmingly, as the polar ice caps melt, we have become aware that sea level itself has begun to rise. There must once have been many Venices around the world, given our fondness for living close to water. Tenochtitlan, the Aztec city in the Lake of Mexico, originally had floating flower gardens, canals and brightly painted houses. It's now buried, together with its lake, under a vast sea of concrete. Suzhou in China is the sad, much-diminished relic of another watery paradise.

Venice itself, the most exquisite expression of humanity's love affair with water, stands on the front line of global warming and may soon be lost under the rising waters of the Adriatic. It could be argued that we can't place the preservation of the past above people's survival, but these can't be separated out so easily. As anyone with any knowledge of dementia knows, little is left of human life when memory goes. Living solely, and desperately, in the present, without a history, is a frightening impoverishment, an unlooked for side effect in China when it swept away aeons of civilisation in its attempt to modernise its masses during the Cultural Revolution. Culture is a precious if intangible asset and it requires conscious preservation and nurturing if it is to develop. The thin red line of fire that is consuming both natural and human history around the world leaves in its wake ashen wastes of destitution and despair.

We don't have the right images to deal with the disaster that faces us. The concept of a 'tipping point' – when we will no longer be able to prevent the slide down into a drastic alteration of world weather patterns – evokes the horizontal plane of an altar balanced on the point of a pyramid, morphing into a pair of scales, with the accumulated authority of all three. It implies that the solution to our problems is to maintain 'the balance of nature'. It also suggests that we've still got time. Both of these have great appeal to politicians. Walking tightropes and maintaining the status quo by avoiding or delaying decisions that might lose them power is what they're good at. But in our current plight we can't just 'maintain a balance' by, say, trading carbon emissions, to give one crude example, and think that will solve the problem. Nature isn't balanced; it's a complex interplay of countless different factors. Life is built up of cells with semi-permeable walls that enable living organisms to feed, grow and reproduce, brains to learn and wounds to heal. The world is a sphere, not a plane, and we need rounded, not planar, thinking to

tackle the problems we face. This means rejecting outdated, simplistic and destructive divisions in politics between right and left, in sexuality between men and women, and in faith between science and religion, and focusing instead on the much more intriguing and rewarding muddled middle ground in everything.

The invention of the World Wide Web, unimaginable a mere quarter of a century ago, has strengthened the faith we have in science-based technical advance, the key to the hopes of the Enlightenment. The Web was the product not just of technological brilliance, but of the egalitarian aspirations of, among others, Tim Berners-Lee, who realised that the network that was being created could be made available to everyone and not just serve commercial or political, military or security interests. There is increasing concern that these hopes are being only imperfectly realised. Although we have now established an extraordinary, invisible bubble of communications around the globe that gives us almost instant access to anyone, this doesn't mean that science by itself will solve all our problems and allow us to go on doing what we've always done.

There is a strong possibility that we've reached the limit of technologically enhanced seeing, first opened to us four hundred years ago with the chance invention of the telescope. After all, we can now no longer examine subatomic entities, the fundamental constituents of the stuff of the world, without changing what they are. CERN might turn out to be our last peephole out of this world, not a window opening on to a new one. It's possible that we will realise, once again, that we're living in a sphere of mystery, as the great minds of the past from Confucius to Socrates to Leonardo always maintained. In 2013, the Planck satellite space observatory tracked variations in the cosmic microwave background on what scientists call the 'horizon' of the universe, which indicated that there could be universes beyond and before our universe. No one before

us has ever got to the ends of the world, and neither have we. It could be that, again like Don Marcelino in the cave at Altamira, we are looking in the wrong direction, at the distant horizons of smallness and largeness, in our attempts to discover the equations that hold them together, when we could be looking at the place where we know they meet, in the mind's eye, in the sphere of human consciousness, in our ability to see and understand which has so far eluded our comprehension.

Our awareness of our own finiteness is the key difference between us and other species, including perhaps our nearest relative, the Neanderthals, a difference that might explain why we made art and they didn't, the point in the story where this book began. Great works of art always encompass the totality of our experience, our love of life and our fear of death. Art is about reality, but it isn't real in the sense of being material. The pyramids, the Taj Mahal and the Sydney Opera House, the *Mona Lisa*, *The Scream* and *Nighthawks* exist only in the sphere of our collective consciousness, in our inexplicable ability to know what others are thinking, in the luminous, imaginative space that exists in our minds and between our minds, in this swirling, shining, sometimes muddled, sometimes clear common sense of purpose that binds the whole human species together into one, and distinguishes us from all other animals, a sphere as unique, perhaps, as the beautiful, swirling atmosphere of our planet in the universe.

We take our collective consciousness so much for granted that we assume it's not there, yet it's the most precious thing we have, the focus of most of our attention, in both our personal and public lives, the sole foundation for our hopes and the safety net for all our fears. This sphere of reality has so far eluded scientific examination because it's immaterial, and yet we know it exists for it is the very stuff out of which science itself grows. We manifest our collec-

tive consciousness daily when we beam selfies to our friends around the globe, every time we catch up with the news, when we Google bird's-eye views of where we are on earth or when, at its simplest and most magical level, we engage in ordinary conversation. The great art of the past grew within this luminous, insubstantial sphere. Mankind's future and that of our planet depend on the fullest possible realisation of a new, collective vision.

We can all agree that we want our children and their children to live healthy lives in an unpolluted world where everyone is responsibly free to express their thoughts and feelings. If we don't know where we are or how we got here, we're unlikely to achieve this goal. We need more than practical steps (though many more of these would be welcome): we need an inspiring vision. Our ancestors built vast and beautiful monuments, the products of great collective enterprises. Now the task that faces us is to save our beautiful, solitary planet. This will only be achieved by an immense collective effort. For that we need to re-enchant our world, and share our enchantment with others.

Recommended Reading

This condensed bibliography concentrates on books that I found particularly thought-provoking, in some cases because I disagreed with them. It would have been unwieldy to list the vast number of reference works I have used during a lifetime's research, which can be accessed through library catalogues. The books are arranged by chapter, though many of them influenced my overall argument. I am deeply indebted to Edinburgh City Libraries, particularly their remarkable Fine Art Library, and to the National Libraries of Scotland.

Chapter 1
Flowers of Common Sense

Banks, Marcus and Howard Morphy (editors), *Rethinking Visual Anthropology*. New Haven, Yale University Press, 1997

Boas, Franz, *Primitive Art*. New York, Dover Publications, 1955 (originally published 1927)

Clark, Kenneth, *Landscape into Art*. London, John Murray, 1949

Clark, Kenneth, *Civilisation, A Personal View*. London, BBC, 1969

Gage, John, *Colour and Meaning: Art, Science and Symbolism*. London, Thames & Hudson, 1999

Gombrich, E. H., *The Story of Art*. London, Phaidon, 1950

Oppenheimer, Stephen, *The Real Eve: Modern Man's Journey Out of Africa*. New York, Basic Books, 2003

Frazer, James George, *The Golden Bough: A Study in Comparative Religion* (1890). Introduction by Cairns Craig. Edinburgh, Canongate, 2004

Honour, Hugh and David Fleming, *A World History of Art*. London, Laurence King Publishing, 2009

Morphy, Howard and Morgan Perkins, *The Anthropology of Art: A Reader*. Oxford, Blackwell, 2006

Pääbo, Svante, *Neanderthal Man: In Search of Lost Genomes*. New York, Basic Books, 2014

Rawson, Philip, *Drawing*. Oxford University Press, 1969

Rawson, Philip, *Ceramics*. Oxford University Press, 1971

Roberts, Moss (translation and introduction), *The Three Kingdoms*. University of California Press, 2004

Schama, Simon, *Landscape and Memory*. London, Fontana, 1995

Summers, David, *World History and the Rise of Western Modernism*. New York, Phaidon Press, 2003

Smart, Ninian, *The World's Religions: Old Traditions and Modern Transformations*. Cambridge, Cambridge University Press, 1989

Yates, Frances A., *The Art of Memory*. London, The Bodley Head, 2014 (originally published 1966)

Zeldin, Theodore, *An Intimate History of Humanity*. London, Minerva, 1994

Chapter 2
Body

Auger, Emily E., *The Way of Inuit Art: Aesthetics and History in and beyond the Arctic*. London, McFarland, 2005

Bardon, Geoffrey and James Bardon, *Papunya: A Place Made after the Story: The Beginnings of the Western Desert Painting Movement*. Aldershot, Lund Humphries, 2006

Bahn, Paul, G. and Jean Vertu, *Images of the Ice Age*. Iowa, University of Iowa Press, 1988

Bahn, Paul, G., *The Cambridge Illustrated History of Prehistoric Art*. Cambridge University Press, 1998

Clark, Kenneth, *Animals and Men: Their Relationship as Reflected in Western Art from Prehistory to Today*. New York, William Morrow and Company, 1977

Clottes, Jean and David Lewis-Williams, *The Shamans of Prehistory: Trance and Magic in the Painted Caves*. New York, Harry N. Abrams, 1998

Clottes, Jean, *Return to the Chauvet Cave: Excavating the Birthplace of Art: The First Full Report*. London, Thames & Hudson, 2003

Eck, Diana L., *Darsan: Seeing the Divine Image in India*. New York, Columbia University Press, 1998

Hodder, Ian. *The Leopard's Tale: Revealing the Mysteries of Çatalhöyük*. London, Thames & Hudson, 2006

Horrobin, David, *The Madness of Adam and Eve: How Schizophrenia shaped Humanity*. London, Bantam Press, 2001

Klingender, Francis D., *Animals in Art and Thought to the End of the Middle Ages*. London, Routledge and Kegan Paul, 1971

LaGamma, Alison, *Art and Oracle: African Art and Rituals of Divination*. New York, The Metropolitan Museum of Art, 2000

Spellman, W. M., *A Brief History of Death*. University of Chicago Press, 2014

Laugrand, Frédéric and Jarich Oosten, *The Sea Woman: Sedna in Inuit Shamanism and Art in the Eastern Arctic*. University of Alaska Press, 2008

Morphy, Howard (editor), *Animals into Art*. London, Unwin Hyman, 1989

Vaneechoutte, Mario, Algis Kulinkas and Marc Verhaegen, *Was Man more Aquatic in the Past? Fifty Years after Alister Hardy: Waterside Hypothesis of Human Evolution*. Beijing, Bentham Science Publishers, 2011

Chapter 3
Tree

Bagley, Robert, *Ancient Sichuan: Treasures from a Lost Civilization*. Princeton, NJ, Seattle Art Museum and Princeton University Press, 2001

Basford, Kathleen, *The Green Man*. Ipswich, Brewer, 1978

Blurton, T. Richard, *Hindu Art*. London, The British Museum Press, 1992

Boelscher, Marianne, *The Curtain Within: Haida Social and Mythical Discourse.* Vancouver, University of British Columbia Press, 1988

Braswell, Geoffrey E. (editor), *The Ancient Maya of Mexico: Reinterpreting the Past of the Northern Maya Lowlands.* Sheffield, Equinox, 2012

Coe, Michael D., *The Maya.* London, Thames & Hudson, 1966

Fagg, William, *Divine Kingship in Africa.* London, British Museum, 1970

Fletcher, John, *Gardens of Earthy Delight: The History of Deer Parks.* Oxford, Windgather, 2011

Gammage, Bill, *The Biggest Estate on Earth – How Aborigines made Australia.* Sydney, Allen and Unwin, 2011

Harris, Victor, *Shinto – The Sacred Art of Ancient Japan.* London, British Museum, 2001

Hohler, Erla Bergendahl, *Norwegian Stave Church Sculpture.* Oslo, Scandinavian University Press, 1999

Lindow, John, *Norse Mythology: A Guide to the Gods, Heroes, Rituals, and Beliefs.* Oxford University Press, 2001

Rawson, Philip, *Erotic Art of the East: The Sexual Theme in Oriental Painting and Sculpture.* New York, Putnam, 1968

Punja, Shobita, *Divine Ecstasy: The Story of Khajuraho.* New Delhi, Viking Penguin Books India, 1992

Zohary, Daniel and Maria Hopf, *Domestication of Plants in the Old World.* Oxford University Press, 2000

Chapter 4
Pyramid

Berrin, Kathleen and Virginia M. Fields, *Olmec: Colossal Masterworks of Ancient Mexico.* New Haven, Yale University Press, 2010

Berrin, Kathleen and Esther Pasztory, *Teotihuacan: Art from the City of the Gods.* London, Thames & Hudson, 1993

Corteggiani, Jean-Pierre, *The Egypt of the Pharoahs at the Cairo Museum.* London, Scala Books, 1987

Corteggiani, Jean-Pierre, *The Great Pyramids.* New York, Harry N. Abrams, 2007

Freed, Rita F., Yvonne J. Markowitz and Sue H. D'Auria, *Pharoahs of the Sun: Akhenaten, Nefertiti and Tutankhamen.* London, Thames & Hudson, 1999

Heyerdahl, Thor, *Kon-Tiki Expedition.* London, Allen and Unwin, 1950

Reeves, Nicholas, *The Complete Tutankhamun – The King, the Tomb, the Royal Treasure.* New York, Thames & Hudson, 1990

Stierlin, Henri, *The Maya: Palaces and Pyramids of the Rainforest.* Cologne, Taschen, 1997

Chapter 5
Altar

Graves, Robert, *The Greek Myths.* London, Penguin, 2011

Gibson, Alex M., *Stonehenge and Timber Circles.* Stroud, Tempus, 1998

McKenna, Terence, *Food of the Gods: The Search for the Tree of Knowledge: A Radical History of Plants, Drugs and Human Evolution.* London, Rider, 2002

Nicoll, Allardyce, *World Drama from Aeschylus to Anouilh.* London, Harrap, 1976

Rawson, Philip, *The Art of Tantra – the Indian Cult of Ecstasy.* London, Thames & Hudson, 1973

Portal, Jane (editor), *The First Emperor: China's Terracotta Army.* London, British Museum Press, 2007

Rimer, J. Thomas and Masakazu Yamazaki, *On the Art of the Nō Drama: The Major Treatises of Zeami*, Princeton University Press, 1984

Schmidt, Klaus, *A Stone Age Sanctuary in South-Eastern Anatolia.* Heidelberg, ArchaeNova, 2007

Spivey, Nigel, *Understanding Greek Sculpture: Ancient Meanings, Modern Readings.* London, Thames & Hudson, 1996

Chapter 6
Veil

Armstrong, Karen, *A History of God: From Abraham to the Present: The 4000-Year Quest for God*. London, Heinemann, 1993

Buckland, Rosina, *Shunga: Erotic Art in Japan.* London, British Museum Press, 2010

Boyce, Mary, *A History of Zoroastrianism.* Leiden, E. J. Brill, 1989

Heath, Jennifer (editor), *The Veil: Women Writers on its History, Lore and Politics.* Berkeley, University of California Press, 2008

Jacobs, Michael and Francisco Fernandez, *Alhambra.* London, Frances Lincoln, 2000

Keswick, Maggie, *The Chinese Garden: History, Art and Architecture.* London, Frances Lincoln, 2003

Rowley, George, *Principals of Chinese Painting.* New Jersey, Princeton University Press, 1959

Sullivan, Michael, *Symbols of Eternity: The Art of Landscape Painting in China.* Oxford, Clarendon Press, 1979

Chapter 7
Through a Glass, Darkly

Baxandall, Michael, *Painting and Experience in Fifteenth-Century Italy: A Primer in the Social History of Pictorial Style.* Oxford, Clarendon Press, 1972

Belting, Hans, *Hieronymus Bosch: Garden of Earthly Delights.* Munich, Prestel Verlag, 2002

Bertman, Stephen, *The Genesis of Science: The Story of Greek Imagination.* New York, Prometheus Books, 2010

Camille, Michael, *Master of Death: The Lifeless Art of Pierre Remiet, Illuminator.* New Haven and London, Yale University Press, 1996

Clark, Kenneth, *The Nude: A Study in Ideal Form.* London, John Murray, 1956

Donnan, Christopher B., *Moche Portraits from Ancient Peru.* Texas, University of Texas Press, 2004

Ferguson, Niall, *The Ascent of Money: A Financial History of the World.* London, Penguin, 2008

Gibbon, Edward, *The Decline and Fall of the Roman Empire – Edited and Abridged with an Introduction and Appreciation by Hugh Trevor-Roper.* London, Phoenix, 2005

Huizinga, Johan, *The Waning of the Middle Ages: A Study of the Forms of Life, Thought and Art in France and the Netherlands in the Fourteenth and Fifteenth Centuries.* 1924. Translated by F. J. Hopman. London, Penguin, 2001

Needham, Joseph, *Science and Civilisation in China* (7 volumes). Cambridge University Press, 1954–2004

Impey, Oliver and Arthur MacGregor, *The Origins of Museums: The Cabinet of Curiosities in Sixteenth- and Seventeenth-Century Europe.* London, House of Stratus, 2001

Rocke, Michael, *Forbidden Friendships: Homosexuality and Male Culture in Renaissance Florence*. Oxford University Press, 1996

Scully, Vincent, *The Earth, The Temple and The Gods – Greek Sacred Architecture*. New Haven and London, Yale University Press, 1979

Tillyard, E. M. W., *The Elizabethan World Picture*. London, Chatto and Windus, 1943

Wolpert, Lewis, *The Unnatural Nature of Science*. Harvard University Press, 1994

Yates, Frances A., *The Rosicrucian Enlightenment*. London, Routledge and Kegan Paul, 1972

Chapter 8
The End of the Rainbow

Badt, Kurt, *The Art of Paul Cézanne*. London, Faber and Faber, 1956

Badt, Kurt, *John Constable's Clouds*. London, Routledge and Kegan Paul, 1950

Baxandall, Michael, *Shadows and Enlightenment*. New Haven and London, Yale University Press, 1995

Berger, Harry, *Caterpillage: Reflections on a Seventeenth-Century Dutch Still Life Painting*. New York, Fordham University Press, 2011

Browne, Sir Thomas, *Religio Medici; and Hydriotaphia or Urne-buriall*, edited and with an introduction by Stephen Greenblatt and Ramie Targoff. New York, New York Review Books, 2012

Claire, Jean, *Cosmos: from Romanticism to the Avant-Garde*. New York, Prestel, 1999

Darwin, Charles, *On the Origin of Species by the Means of Natural Selection*. London, John Murray, 1859

Gogh, Vincent van, *The Complete Letters*. London, Thames & Hudson, 2000

Greenblatt, Stephen, *The Swerve: How the Renaissance Began*. London, Vintage, 2011

Hilton, Tim, *John Ruskin* (volumes 1 and 2). New Haven and London, Yale University Press, 1985 and 2000

Holmes, Richard, *The Age of Wonder: How the Romantic Generation Discovered the Beauty and Terror of Science*. London, Harper Press, 2008

Holmes, Richard, *Shelley: The Pursuit*. London, Weidenfeld and Nicolson, 1974

Kemp, Martin, *The Science of Art: Optical Themes in Western Art from Brunelleschi to Seurat*. New Haven and London, Yale University Press, 1990

Kemp, Martin, *Visualisations: The Nature Book of Art and Science*. Oxford University Press, 2000.

Klingender, Francis D., *Art and the Industrial Revolution*. London, Evelyn, Adams and Mackay, 1968

Johnson, E. D. H., *Paintings of the British Social Scene from Hogarth to Sickert*. London, Weidenfeld and Nicolson, 1986

Piper, David (Malcolm Rogers, editor), *The English Face*. London, National Portrait Gallery, 1992

Schama, Simon, *Rembrandt's Eyes*. London, Allen Lane, 1999

Swank, Scott T., *Shaker Life, Art and Architecture – Hands to Work, Hearts to God*. New York, Abbeville Press, 1999

Uglow, Jenny, *The Lunar Men: The Friends Who Made the Future, 1730–1810*. London, Faber, 2002

Wingfield Digby, George, *Symbol and Image in William Blake*. Oxford, Clarendon Press, 1957

Chapter 9
Glimpses of Enchantment

Berger, John, *Permanent Red: Essays in Seeing*. London, Methuen, 1960

Berger, John, *Ways of Seeing*. London, BBC, 1972

Chang, Jung, *Wild Swans*. London, Harper Collins, 1991

Dawkins, Richard, *The God Delusion*. London, Bantam Press, 2006

Diamond, Jared, M., *Guns, Germs and Steel – A Short History of Everybody for the Last 13,000 years*. London, Vintage, 2005

Ekhert, A. Roger, *At Day's Close: A History of Nighttime*. London, Weidenfeld and Nicolson, 2005

Hughes, Robert, *The Shock of the New: Art and the Century of Change*. London, Thames & Hudson, 1991

Richardson, John, *A Life of Picasso* (3 volumes). London, Jonathan Cape, 1991–2007

Sereny, Gitta, *Albert Speer: His Battle with Truth*. London, Macmillan, 1995

Tallis, Raymond, *The Explicit Animal: A Defence of Human Consciousness*. London, Macmillan, 1991

Tallis, Raymond, *Newton's Sleep: The Two Cultures and the Two Kingdoms*. London, Macmillan, 1995

Tallis, Raymond, *Michelangelo's Finger: An Exploration of Everyday Transcendence*. London, Atlantic, 2010

Tuckman, Maurice (editor), *The Spiritual in Art: Abstract Painting 1890–1985*. New York, Abbeville Press, 1987

Watson, Peter, *A Terrible Beauty – A History of the People and Ideas that Shaped the Modern Mind*. London, Weidenfeld and Nicolson, 2000

Index

Index